Hotel Mariachi

Querencias Series

Miguel A. Gandert
and Enrique R. Lamadrid,
Series Editors

Querencia is a popular term in the Spanish-speaking world used to express love of place and people. This series promotes a transnational, humanistic, and creative vision of the U.S.-Mexico borderlands based on all aspects of expressive culture, both material and intangible.

Other titles in the Querencias series available from the University of New Mexico Press:

Sagrado: *A Photopoetics Across the Chicano Homeland* by Spencer R. Herrera, Robert Kaiser, and Levi Romero.

Hotel Mariachi

URBAN SPACE AND CULTURAL HERITAGE IN LOS ANGELES

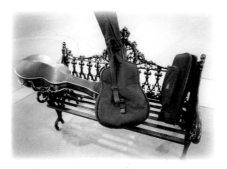

ESSAYS BY CATHERINE L. KURLAND AND ENRIQUE R. LAMADRID
PHOTOGRAPHS BY MIGUEL A. GANDERT

UNIVERSITY OF NEW MEXICO PRESS
ALBURQUERQUE, NEW MEXICO

UNM Press gratefully acknowledges the support of **Bernay Grayson,** whose generosity helped make publication of this book possible.

The Querencias Series and UNM Press wish to thank these donors for their contributions:

LA Plaza de Cultura y Artes, Los Angeles
East LA Community Corporation

Text © 2013 by Catherine L. Kurland and Enrique R. Lamadrid
Photographs © 2013 by Miguel A. Gandert
All rights reserved. Published 2013
Printed in China
18 17 16 15 14 13 1 2 3 4 5 6

Library of Congress Cataloging-in-Publication Data

Hotel Mariachi : urban space and cultural heritage in Los Angeles / essays by Catherine L. Kurland and Enrique R. Lamadrid; photographs by Miguel A. Gandert.
 pages cm. — (Querencias)
 English and Spanish.
 Includes bibliographical references and index.
 ISBN 978-0-8263-5372-6 (pbk. : alk. paper) — ISBN 978-0-8263-5373-3 (electronic)
1. Boyle Hotel (Los Angeles, Calif.)—Pictorial works. 2. Historic buildings—California—Los Angeles—Pictorial works. 3. Hispanic Americans—California—Los Angeles. 4. Popular culture—California—Los Angeles. I. Gandert, Miguel A. II. Kurland, Catherine L., [date]– Pobladores to mariachis. III. Lamadrid, Enrique R., Paean to Santa Cecilia, her fiesta, and her mariachis. IV. Title.
 TX941.B694H68 2003
 919.794'9406—dc23
 2013000148

DESIGN AND COMPOSITION: Catherine Leonardo
Composed in 11/14 Adobe Garamond Pro
Display type is Brioche

Contents

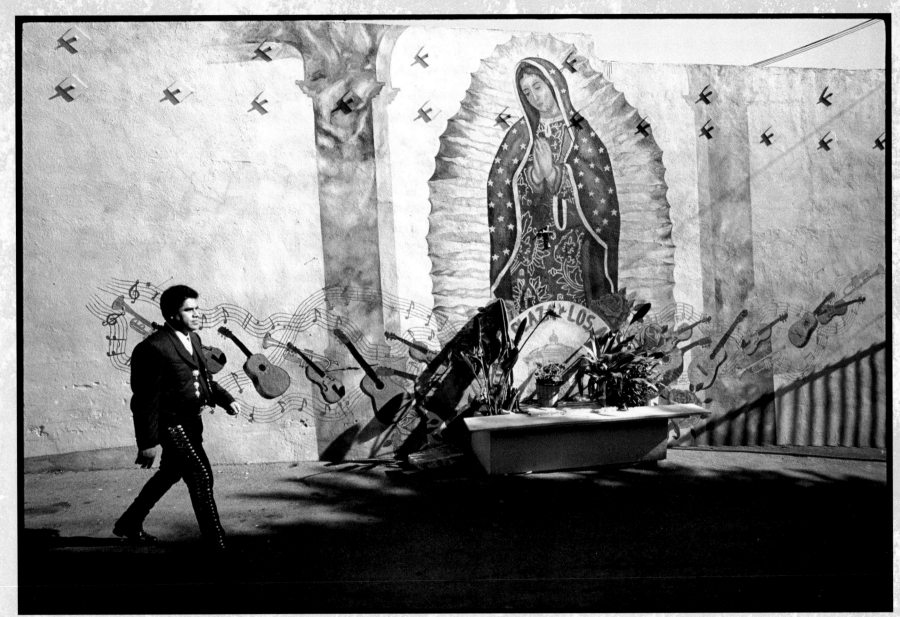

Madre de los mariachis / Mother of Mariachis

Introduction

Evangeline Ordaz-Molina

When the East LA Community Corporation (ELACC) had the opportunity to purchase the Boyle Hotel-Cummings Block in late 2006, it was what they call in real estate parlance an "emotional purchase." Situated across the street from Mariachi Plaza, the Mariachi Hotel, as it was known in the 'hood, was literally a slum. The building had hardly been updated since it was built in 1889. Four to six men shared small hotel rooms that lacked bathrooms or kitchens. Common bathrooms, one to a floor, were sloppily constructed without permits. This was a building that no one should have purchased. But, when we founded ELACC in 1995, it was precisely to renovate buildings like this and maintain them as affordable housing for the low-income residents of Boyle Heights and East Los Angeles, while at the same time preserving neighborhood assets. And the "Mariachi Hotel" was definitely a neighborhood asset. For as long as any of us could remember it housed itinerant mariachi musicians. These musicians used to sit on the benches in front of a donut shop across the street from the hotel, sipping coffee, playing chess, and gossiping, while they waited for neighborhood residents to drive up and hire a mariachi band to play at a baptism, wedding, *quinceañera*, or to serenade a lover.[1]

It was only later that we discovered, after meeting Catherine López Kurland, that the building had a history befitting its current residents. Catherine is a descendant of some of the founders and earliest residents of Spanish and Mexican Los Angeles and she very generously shared her extensive research on her family with us. The land on which the hotel sits belonged to her great-great-grandfather, Francisco "Chico" López, and before him his father, Estevan. Estevan gave the land to his daughter Sacramenta López when she married George Cummings and, twenty years later, they built the hotel. Although the Victorian architecture is evidence of the increasing Anglo influence of the late 1800s, the hotel was built on land that belonged to the Mexican *pueblo* that was Los Angeles. Catherine has given us the gift of her family's history, which is actually the history of all Angelenos. This history securely grounds mariachi culture in Mariachi Plaza and Los Angeles.

I was born just one block from the Mariachi Hotel and Mariachi Plaza. So, when I returned to the neighborhood after law school, I would drive by the hotel and donut shop (the plaza was still just a traffic triangle with a donut shop sitting on it) just to catch a glimpse of the romantic figures in their tight black suits with silver buttons running up the sides of their pants and white embroidery decorating their short black jackets. You see, for every Mexican, and I mean *every* Mexican, whether you live in Mexico or not, mariachi music is no less than the cry of your soul. When we hear that first strum of the mariachi guitar our hearts literally flutter, and when the violins and trumpets join in our lungs fill. I can still hear my grandmother's *grito* "¡*Ajúa, ajúa! ¡Échale!*" as she gave vocal expression to the action of the heart upon hearing those first notes.[2] And for those of us who danced ballet *folklórico* as children, we must consciously hold our feet fast to the ground to prevent them from executing

1 The quinceañera is the festive coming-of-age party for girls turning fifteen.

2 The grito is a spontaneous cry that accompanies climactic moments in mariachi music.

sloppy steps in time to the music.[3] A shot of tequila later and we no longer care that our dancing is amateur and the grandmothers are singing along. For me, the music is a combination of abject nostalgia and an amazing validation of who I am. The history of the Mexican people, both in the United States and Mexico, has been so full of tragedy and oppression that it is hard not to grow up with a sense of deficiency. Before I knew what race or ethnicity I was, I felt mine was somehow "less than." But, when I hear mariachi music, or *jarocho*, or *ranchero*—anything homegrown in Mexico or East L.A.—I know that I do not lack.[4] In fact, if my ancestors created this, then there must be some potent stuff in our blood and we cannot be less than anyone else on earth.

Enrique Lamadrid's poetic exploration of the history of mariachi and the mariachi's relationship to his or her patron saint Santa Cecilia has turned my romance with the music into an abiding love. Enrique's writing vividly takes us to a celebration of mariachi's most holy day, the feast of Santa Cecilia. It is a celebration that starts with a dawn procession with hundreds of mariachis singing the Mexican birthday song to Santa Cecilia. Enrique's analysis of the lyrics of this song and many others gives us insight into the Mexican psyche, which utilizes metaphor and clever turns of phrase to express the many identities Mexicans have inherited. Enrique's research solidly situates the music at a crossroads of Europe, Africa, and indigenous America. Reading his essay, I finally understood why mariachi music feels as if it has thrown its arms open wide to embrace the entire world. *Un abrazo cósmico* from *la raza cósmica*.[5] And I finally learned the words to "La Negra," my all-time favorite mariachi song. Thank you, Enrique!

The men (and a few women) in East L.A. who make the music that gives voice to the heart of an entire people are both blessed and cursed. When they play they are gods. But when they put down their instruments and remove their *trajes*, they are no different from any other low-income laborer in East L.A.[6] In fact many of them do labor on construction crews or in hotel kitchens in order to afford to play this music that keeps our hearts pumping. Even the business of selling mariachi music is conducted much like other day labor is transacted in Los Angeles. Mariachis wait for customers at the donut shop, turned plaza, turned metro station, on the corner of First and Boyle in Boyle Heights, and when the customers arrive they negotiate a price, get an address, and four or five musicians get into a car and go.

Miguel Gandert's photographs joyously and heartbreakingly capture this dichotomy. He depicts the regal dignity of a band at play alongside the harsh reality of the struggle for work. Miguel so completely captures the music of the mariachi life that the photographs themselves sing. Miguel's talent lies in his understanding of the struggle to make art that literally sustains a people. When Miguel photographs a mariachi, he knows the value of this image and how necessary it is to preserve a culture that often feels like it is being strangled by modernity. (The donut shop is long gone and the Mariachi Plaza metro station is more metro station than plaza.) Miguel's photographs have already helped ELACC to effectively tell the story of the mariachis in the Mariachi Hotel, aiding us in our efforts to successfully raise the funds needed to renovate the space into a safe and habitable home for mariachis and their music. With the photographs in this book, Miguel has staked out even more space for the preservation of mariachi culture.

In our minds at ELACC, the walls of the Mariachi Hotel hold the keepers of the Mexican musical heart close at hand, where residents of the 95 percent Latino neighborhood of Boyle Heights and others can always access them. Once ELACC became owner of the property we began meeting with the mariachi residents to find out how else the building might support the music in addition to high-quality

3 Ballet folklórico is the repertory of regional Mexican folk dances taught in schools all over greater Mexico.

4 Jarocho is regional folk music from Veracruz, and ranchero is Mexican country music.

5 A "cosmic embrace" from the "cosmic race" is a reference to the famous book by philosopher José Vasconcelos, who said that Mexicans are the cosmic fusion of all the world's races.

6 Trajes are the musicians' silver-buttoned suits.

affordable housing. Our idea of a performance space was quickly dismissed in favor of a facility that would support the economic viability of life as a mariachi musician. In addition to housing, the mariachis asked for help professionalizing their work. They asked for rehearsal space where they could practice without disturbing neighbors. They asked for recording equipment to make samples of their work in order to promote it. They asked for office space and computer facilities so they could establish an online presence to advertise their services. They asked for instrument and costume storage to better protect the tools of their trade. The mariachis know better than to want to contain their art in a stationary venue. They want support that will enable them to continue to take their music, Mexican music, into the houses, event halls, and streets of East L.A. and beyond. In this way they pay homage to the Mexican roots of the Mariachi Hotel.

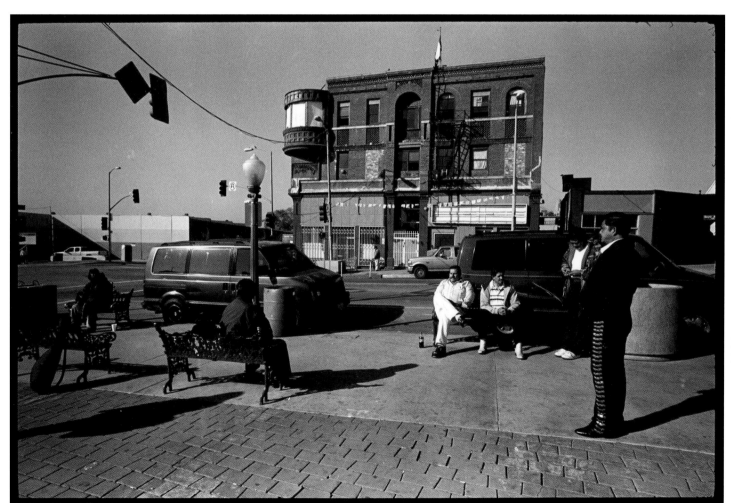

Entre tocadas /
Between Gigs

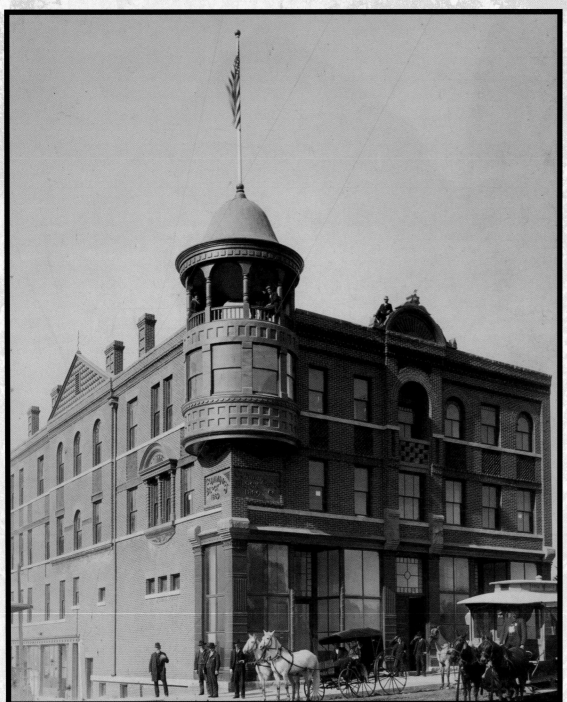

The Cummings Block, c. 1889. It is probably George Cummings who is sitting on the roof near the central pediment, and William H. Workman is standing by himself on the left. Courtesy of the Workman Family Collection.

Pobladores to Mariachis

A Personal Journey

Catherine L. Kurland

One spring day in 2003, I crossed a border—the Los Angeles River—to get to Boyle Heights. My niece Suzanne and I were driving from Santa Monica to an unfamiliar part of Los Angeles, known outside the neighborhood mostly for occasional eruptions of gang activity—fodder for the *Los Angeles Times*. It seems that everyone in Los Angeles zooms past Boyle Heights on the three freeways that carved it up in the 1950s, but few explore its surface streets. We were headed to La Serenata de Garibaldi, a destination Mexican restaurant. After exiting the freeway, we found the restaurant's parking lot off an alley in the back, where an attendant opened our doors and whisked away our station wagon. We ascended an exterior staircase to the back entry that opened into a large room filled with the hum of well-dressed Latino families enjoying Sunday lunch. After consuming generous portions of delicious *huevos rancheros* and a couple of refreshing Carta Blancas, we decided to walk some of it off before returning home.

We emerged from the cool dark interior into the bright midday sun on First Street, adjusted our eyes to the glare, and started walking down the street. As we rounded the corner, there, straight ahead of us, at the top of a hill overlooking the skyscrapers of downtown Los Angeles, was a four-story brick Victorian building on the northwest corner of First and Boyle. We recognized it immediately—the Cummings Hotel! My mother and her sisters had often spoken of a grand hotel built by their grandfather, where their very proper grandmother received visitors in the afternoons. Although I had grown up in Los Angeles, I had never seen it. Here was the building, still standing and in mostly original

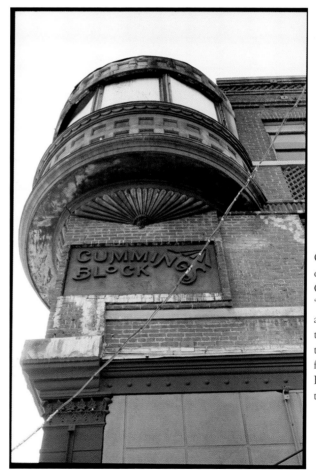

Orgullo del *'49er* / Pride of the '49er. George Cummings was a "forty-niner" who arrived by ship in 1849 to seek his fortune in the gold fields of California. The Cummings Block was the culmination of his dream.

condition, thanks to benign neglect. The bronze lettering, "Cummings Block," was clearly visible.

When we spotted a man in a black suit opening the door, we dashed inside the hotel and scrambled up a long staircase behind him. At the top of the stairs, stopping to catch our breath, we looked around and found ourselves in the middle of a group of men, many in elaborate suits, and others in various states of undress. Then it dawned on us—we were surrounded by mariachi musicians! The Cummings Hotel was now the Boyle Hotel, better known as the Mariachi Hotel.

Following the mariachi up the stairs was like Alice following the rabbit down the rabbit hole. A world opened up and swallowed me, one that fundamentally changed my perception of my family history and myself. This hotel became the link to my Latina heritage. For others as well, the Cummings Block, built in 1889 on land belonging to a Hispanic Californian, is a tangible connection between the thriving Mexican American and Mexican immigrant population in Boyle Heights today and that of the 1800s, when the Spanish-speaking *Californios* were still the dominant group.[1] The music of the mariachis in the hotel and on Mariachi Plaza outside its doors reaches out to the vast Mexican population in the neighborhood and throughout the region.

"'A Ship, A Ship,' exclaimed Father Salvidea,'" when Claudio López arrived at the port of San Diego from Spain before proceeding by land to Mission San Gabriel.[2] That exclamation is the first line in *Claudio and Anita: A Historical Romance of San Gabriel's Early Mission Days,* our family's foundational fiction, which my great-grandmother María del Sacramento López y Almenares de Cummings, or Sacramenta, wrote in 1921. In fact, her grandfather Claudio López served as mayordomo of this mission for nearly twenty years, under the supervision of Fray José María de Zalvidea.[3]

The hotel had drawn me back into my mother's ancestry, leading me to re-read this little novel. Until Mariachi Hotel became a part of my life, my knowledge of my family history was based on our own Spanish fantasy heritage as depicted in my great-grandmother's book.[4]

I had not questioned how my maternal forebears had been catapulted from eighteenth-century Spain directly to Alta California without setting foot in Nueva España (Mexico), as recounted by my mother and aunts and by Sacramenta. By the time she published *Claudio and Anita,* only fiction could resurrect the history of her family and other dispossessed Californios who were struggling to recapture their dignity, if not their long-lost economic, political, and social power. While ferreting out threads of truth woven through Sacramenta's florid prose, I discovered something more potent than I had imagined—my roots in the Mexican *pueblo* of Los Angeles and Boyle Heights.

After the thrill of discovering that the Cummings Hotel was a residence for mariachis, Suzanne and I were intent on uncovering the facts about Claudio López—and learning about the hotel's history. Our research soon expanded beyond our original goal of recovering the lost history of don Claudio, portrayed in the book as a young man of noble birth, who left his comfortable home in northern Spain to serve God and country by sailing to the New World and becoming mayordomo of Mission San Gabriel, the most prosperous of all the California missions.

In his introduction in *Claudio and Anita,* John McGroarty, author of the long-running San Gabriel *Mission Play,* calls Mrs. Cummings's book "a true tale. . . . Mrs. Cummings is a new master of that old art of clothing truth in fiction's shining garb."[5] Reading it sparked an all-consuming need to find the history within the fiction. While researching the life of don Claudio, I discovered much, much more. For one thing, I learned that Claudio was born in Baja California, as were his parents, and that his grandparents had migrated from northern Spain in the 1600s. Don Claudio was at the Mission San Gabriel by 1782.

To my surprise, I found out that some of our ancestors arrived in southern California even earlier than don Claudio, from the states of Jalisco, Sonora, Sinaloa, and Nayarit on the west coast of Nueva España, and from Baja California. While I pored over documents at the Huntington Library, the repository for letters about López family

history written by Sacramenta's sister Francisca López de Belderraín, my niece explored cyberspace and hit pay dirt. While surfing the Internet, she made the virtual acquaintance of cousin Robert (Bob) E. López, also a direct descendant of Claudio López. As the genealogist for Los Pobladores 200, descendants of the eleven founding families of Los Angeles and their four escort soldiers, cousin Bob filled in and documented the branches on our family tree going back to the late 1600s in Nueva España. (Bob also showed me our relationship to our López cousin Linda Ronstadt!) He informed us that our ancestors included one of the founding families of Los Angeles: Luis Manuel Quintero, a *negro* tailor from Guadalajara, Jalisco; his wife, María Petra Rubio, a *mulata* from Alamos, Sonora; and their five children.[6] We also learned that we are descended from one of the pobladores' four escort soldiers, Roque Jacinto de Cota, an *español* from El Fuerte, Sinaloa.

Los Pobladores 200 was established in 1981 to coincide with the bicentennial of the founding of Los Angeles. Cousin Bob, as head of membership for the group, was responsible for verifying applicants' eligibility. His research brought to light the African, Native American, and European origins of the first families—news to many of their descendants. Some pobladores were displeased when the bronze plaque installed at the Los Angeles Plaza in 1981 listed the castas or castes of the founders: with the exception of two españoles, all were negros, mulatos, *mestizos*, or *indios*.[7] On the northern frontier of Mexico, where *mestizaje* or racial hybridity was well established, there was said to be little stigma attached to the various castas. Among the Spanish colonial settlers of California, Mexican Indians who spoke Spanish and adopted the dress and cultural ways of non-Indians could join the ranks of the more fair-skinned or European-descended *gente de razón*, the people of reason, as they called themselves.[8]

Under orders from King Carlos III of Spain, California Governor Felipe de Neve instructed his lieutenant governor, Fernando Rivera y Moncada, to recruit colonists for the new pueblo. In February 1781, *Alférez* (Second Lieutenant) José de Zúñiga and Alférez Ramón Laso de la Vega led soldiers and families from Álamos, Sonora, across the Sea of Cortez to Loreto, Baja California. From there, by foot, horseback, and mule, they traveled five hundred miles north along the royal road, El Camino de las Californias, to Mission San Gabriel.[9] After resting at the mission for about six weeks because of an outbreak of smallpox among the children, the settlers set off on the final leg of their journey, to the designated pueblo site on the west bank of the Río Porciúncula.[10] The official (if not actual) date of the founding of El Pueblo de la Reina de Los Ángeles is September 4, 1781.[11]

Two hundred twenty-five years later, on September 4, 2006, Suzanne, our cousin Carla, and I, adorned in the distinctive red sashes

Primo Bob López / Cousin Bob López. Robert E. López and his wife, Margaret.

of the pobladores, set off at dawn from Mission San Gabriel to follow in the footsteps of our ancestors' nine-mile walk to the Los Angeles Plaza. This procession was a watershed in my odyssey. It was on this day that I first met cousin Bob López and his beautiful wife, Margaret, in person. Bob was a young eighty-three-year-old with a twinkle in his eye and an exhaustive knowledge of Californio genealogy. We met members of our López clan and other pobladores, almost all of whom were relations, however distant. We were part of an extended Mexican family.

From cousin Bob's church records, we learned that José María Claudio López y de la Mora was born in 1767 in Real de Santa Ana, a mining settlement near La Paz, Baja California Sur. In 1782, one year after the colonists founded the pueblo of Los Angeles, Claudio López was confirmed by Junípero Serra at nearby Mission San Gabriel, where he married María Luisa Cota y Verdugo in 1789, daughter of pobladores escort soldier Roque Jacinto de Cota.[12] We knew that in the early 1800s don Claudio had been mayordomo of Mission San Gabriel, where he is buried under the holy font inside the church. However, only recently did we learn that he is credited with overseeing the construction of El Molino Viejo, the mission's water-powered gristmill completed in 1812, the first in California, and that he was a *regidor* or city councilmember and *alcalde*, mayor, of the Mexican pueblo of Los Angeles in 1826.[13] After moving to Los Angeles from his adobe in the San Gabriel Valley not long after Mexican Independence in 1821, he "sat on the veranda of his Los Angeles home, watching the same eternal sun, declining into the evening frame of the misty clouds arising from the Pacific."[14] This was situated on Paredón Blanco, the white bluff east of the river.

In 1835 the status of Los Angeles was elevated in official rank from pueblo to *ciudad*, a city, and named capital of Alta California. That year the *ayuntamiento* or city council voted to give Claudio's son Estevan López, a regidor, permission to build a house on Paredón Blanco, and granted him the land at the bottom of the bluff where he already had been raising livestock and cultivating crops, including wine grapes. He received "a lot for a dwelling house 100 varas square

and the lands that it has below it . . . no obstacles exist to prevent his building a house . . . outside the vineyard and corral."[15] According to a description of Los Angeles in 1850, "the influential López family lived across the river along Paredón Blanco."[16]

Estevan López was married to María Jacinta del Sacramento Valdez, granddaughter of pobladores Luis and María Petra Quintero. In 1841 Estevan and his wife gave "a small tract of land" on Paredón Blanco to their son Francisco Mauricio "Chico" López, the father of my great-grandmother Sacramenta. Sacramenta was born in 1850, the year California became a state and two years after the Treaty of Guadalupe Hidalgo was signed.[17] She grew up in a five-room adobe on Paredón Blanco during the mid-1800s. Her younger sister Francisca describes her own pastoral childhood in fascinating detail in an article she wrote in 1928, "The Awakening of Paredón Blanco under a California Sun."[18]

In 1859 Petra Varelas, the widow and second wife of Sacramenta's grandfather Estevan López, sold the López adobe, farmlands, and vineyards at the bottom of the bluff to a new arrival in town, an Irishman named Andrew Boyle.[19] In 1876 Boyle's son-in-law, William H.

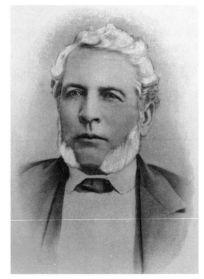

Portrait of Francisco "Chico" López (1818–1900), Kurland's great-great-grandfather. Courtesy of University of Southern California on behalf of the USC Libraries Special Collections.

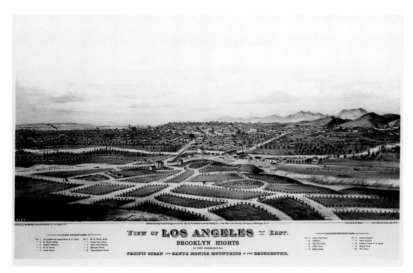

View of Los Angeles from the east with plat of Brooklyn Heights subdivision in the foreground, 1877. The site of the future Cummings Block is in the lower left corner of the map. Reproduced by permission of The Huntington Library, San Marino, California.

In the year 1850, there were but three American families living in Los Angeles—that is, but three families in which both the husband and wife were Americans. . . . The other Americans who had families had married Californian wives, and many had adopted the customs of the paisanos. While the American pioneer was of good stock, and his influence was to build the country more firmly than it had yet been done, the real "aristocracy" of the old City of Los Angeles was composed of the better Spanish families and the names of López, Carrillo, Sánchez, Sepúlveda, Lugo, Domínguez, Aguilar, Pico, Machado, Coronel, Del Valle, Ávila, Garfias, Célis, Reyes, Ruíz, Alvarado, Bandini, Yorba, Vejar, Palomares, Ybarra, and Alanís have always stood out among the leaders, both socially and politically, in early Los Angeles history.[22]

A generation later, Anglo men were still marrying landed Hispanic women. In 1869 Sacramenta López and my great-grandfather George Cummings wed at the Los Angeles Plaza Church. Three years after the

Workman, subdivided the López farmland along with other property on Paredón Blanco, naming it Boyle Heights.

Fortunately, many years before the widow Varelas sold the land, Estevan López had allotted the "small tract of land" to Chico, who built two fine adobes, raised sheep, and planted orchards, vineyards, and even cotton and sugar cane there.[20] Like his future son-in-law George Cummings, Chico made his fortune raising cattle to feed the hungry miners, and later he was one of the largest landowners in southern California. Chico also acquired adjacent acreage that he subdivided; he was a principal investor in the seventy-acre Brooklyn Heights tract, which was said to have been the cause of his financial undoing.[21]

In his *Annals of Los Angeles From the Arrival of the First White Men to the Civil War, 1769–1861*, J. Gregg Layne writes about American husbands and Hispanic California wives:

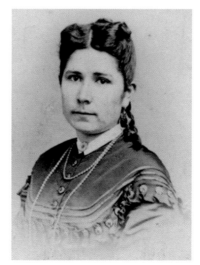

Carte de visite photograph of Sacramenta López de Cummings (1850–1930), c. 1869. Photograph by C. L. Cramer's California Gallery, San Francisco. Courtesy Seaver Center for Western History Research, Los Angeles County Museum of Natural History.

wedding, in 1872, Chico López and María del Rosario Almenares y Cesena de López gave forty-six acres of their Paredón Blanco land to their daughter Sacramenta with "consideration of love and affection."[23] This was probably a belated wedding or dotal gift.

In 1849 George Gerscovich, a Croatian youth (census records list his and his father's country of origin as Austria) had sailed to San Francisco in search of gold. It was said that the ship's captain adopted George, giving him his surname, Cummings, and one hundred dollars.[24] George Cummings had good luck mining in the Sierras, but enjoyed even more success as a farmer and stock raiser. Selling wheat, potatoes, and beef to the hordes of miners, he amassed enough capital by the late 1850s to purchase three thousand acres of valley land and a mountain in Tehachapi for growing crops and raising cattle—the Cummings Ranch.

I know "The Ranch" well. While growing up in Los Angeles, I lived for the day each summer when I would settle into my seat on the Southern Pacific at Union Station for the three-hour train ride to Tehachapi, where my cousins Carla and Robin and I would be welcomed at the ranch in Cummings Valley by our aunts, uncles, and cousins.

Preferring to live in Los Angeles rather than in Tehachapi 115 miles to the north, George Cummings left the management of the ranch to his son Ed and a hired foreman. In 1858 Cummings purchased forty acres in Paredón Blanco. Listed as an "orchardist" in city directories, he planted over two thousand orange trees and fifteen hundred other fruit trees there. Sacramenta and George built a spacious two-story Queen Anne home, where they raised seven children, including my grandfather Francisco "Frank" Cummings y López. According to an article in the *Los Angeles Times* on August 4, 1889, "In 1881 . . . on Boyle Heights there were half a dozen houses, chief among which were the residences of Cummings, Hollenbeck, and W. H. Workman."[25]

Carte de visite photograph of George Cummings (1828–1903), c. 1869. Photograph by C. L. Cramer's California Gallery, San Francisco. Courtesy Seaver Center for Western History Research, Los Angeles County Museum of Natural History.

Boyle Avenue south of East First Street, c. 1888. Just south of the Cummings Block, the López adobes and the Workman residence were sited on this road, which runs along the top of the bluff (Paredón Blanco) facing Los Angeles to the west. Courtesy Workman Family Collection.

Twenty years after their wedding, George Cummings commissioned prominent architect W. R. Norton to build a brick business block on his wife's land. Following the arrival in 1881 of the Southern Pacific railroad on its direct southern route through Deming, New Mexico, and a fare war with the Santa Fe Railroad in 1886 that reduced transcontinental tickets to one dollar, Los Angeles experienced a record-breaking real estate boom. Just one mile east of downtown, Boyle Heights, with its views of the city and refreshing breezes on the bluff, also benefited economically from the influx of newcomers. New subdivisions included the George Cummings Tract and his Mount Pleasant Tract.[26]

A *Los Angeles Times* article from 1889, "Boyle Heights: A Brief Sketch of a Delightful Suburb," shows a drawing of Cummings's Queen Anne house along with a description of its owner:

Mr. Cummings is a '49er, and has lived on the Heights 29 years. He has not only built up for himself and his numerous family a magnificent home, but he has accumulated a large fortune. He came to this city when it was a wild west village. . . . He has always found time to devote himself to the general improvement of Boyle Heights. . . . Mr. Cummings is about to build a large four-story brick block that will be an honor to the Heights.[27]

A record of 1889 Los Angeles applications for building permits includes one from architect William R. Norton for a business block for George Cummings at a cost of $22,000.[28]

George Cummings embodied the optimism of the late 1800s, risking a good portion of his and his wife's fortune on the four-story architect-designed brick building in Queen Anne–Italianate style. The prominent corner cupola and turret—said to have been a tearoom—could be seen from all directions. There were large glass storefronts on Boyle Avenue surrounding a main entry under a stained glass window.

A long staircase led up to the hotel's public areas: a parlor, reading and dining rooms, with guest rooms above—a typical plan for a late nineteenth-century commercial building block and hotel.

Boyle Heights was prospering with new residents, businesses, and amenities in 1889. A streetcar line from downtown Los Angeles was made feasible by the completion of the First Street viaduct across the Los Angeles River, following a successful campaign by William H. Workman, supported by George Cummings. Soon after its opening, the Cummings Block and Hotel was host to business and charitable events—a social nexus for the community. Hotel guests included families and traveling businessmen. Although my mother and aunts did not mention the advertised "tennis courts and croquet grounds," they recounted their grandmother's proud memories of hosting teas and taking carriage rides in the afternoon.

But sadly, Sacramenta's grand life as hotel proprietress was to be short-lived. Only a few years later the great Panic of 1893, the second-greatest depression in our nation's history, which bankrupted the Santa Fe Railroad and closed four banks in Los Angeles, rolled like a tsunami across the West, ruining untold numbers of businesses, including the Cummings Hotel. On December 17, 1894, the Main Street Savings Bank and Trust Company partially released "George Cummings and Sacramento López de Cummings his wife" from their mortgage, in return for real property. The bank took possession of the Cummings Block—and with it, Sacramenta López's inheritance. On her family land, she and her Anglo husband had built their dream. By the close of the century there were few Hispanic names on property maps.

The Cummings Block faces an open area where three streets come together, East First Street, Boyle Avenue (formerly López Street), and Pleasant Street. This space is visible on maps going back to the late 1800s, a triangle created by the rectilinear Anglo street grid bumping up against the organic Hispanic settlement pattern following the topography—an enduring metaphor for the uneasy fit

of the two cultures. According to longtime residents of the neighbor-hood, including Lucy Delgado and Anita Castellanos, whose family owned a barber shop and beauty salon next door to the hotel, this plaza has been a gathering place for mariachi musicians since at least as early as the 1930s, even while other ethnicities moved in and out of Boyle Heights.

The area had evolved from a desirable location for Mexicans in the early and mid-1800s to a fashionable Anglo suburb at the end of the century and, after 1910, to a neighborhood populated with new waves of Mexicans escaping the revolution. What once had been a genteel hotel for families and businessmen became more of a residential hotel.

Boyle Heights has long been identified with its large population of Jewish families from Eastern Europe and other parts of the United States, including my father and his family, who moved from Minnesota in the early decades of the twentieth century. Two other groups with a significant presence were Russian Molokans (a Protestant sect) and Japanese Americans who resided in the area before they were sent to internment camps during WWII. In a 2010 interview for the *Los Angeles Times*, University of Southern California professor George J. Sánchez said that the neighborhood "was viewed with deep suspicion by the U.S. government. In a 1939 federal housing report, Boyle Heights was described as 'hopelessly heterogeneous with diverse and

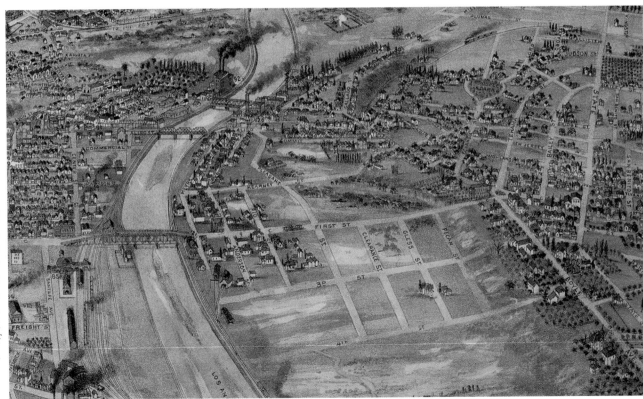

Bird's Eye View of Los Angeles. Detail showing Boyle Heights and East L.A. on the right and downtown Los Angeles across the river. The multistory Cummings Block can be seen at the eastern terminus of East First Street. From a color lithograph by B. W. Pierce. Los Angeles: Semi-Tropic Homestead Co., 1894. Reproduced by permission of The Huntington Library, San Marino, California.

subversive racial elements on almost every single block.'"[29] After the war Boyle Heights was once again predominantly Mexican.

Mariachis have been living in the Boyle Hotel since the 1960s, if not earlier. Here musicians could share an inexpensive room right on the plaza. At a moment's notice an entire group could be down the stairs and in a van setting off for a gig. Since 1998 the defining feature of Mariachi Plaza has been a forty-foot-high kiosk donated by the state of Jalisco, the mariachi heartland of Mexico. It is topped with a statue of Santa Cecilia, patron saint of musicians, which Juan Pablo Salas, a renowned sculptor from Guadalajara, chiseled and then brought to Los Angeles with a crew from Mexico. The stone kiosk sits on the little triangular island where mariachis have assembled for decades—for many years in front of a donut shop at its center.

In 2001, seventeen cast-iron benches representing towns throughout the state of Jalisco were added to the plaza. At the dedication ceremony for the benches, Los Angeles City Councilmember Nick Pacheco acknowledged the role of the musicians: "These benches will celebrate, in perpetuity, the mariachis of Los Angeles who bring their music and vitality to the plaza every day of the year."[30] The City of Los Angeles, the Mexican state of Jalisco, and the Los Angeles Metropolitan Transit Authority (MTA) jointly funded the kiosk. The role of the MTA augured an uncertain future for mariachis in this location: a new Metro station was in the works for Mariachi Plaza and, with it, the likelihood of development and gentrification.

Soon after our lunch at La Serenata de Garibaldi, I found out that the future of the Boyle Hotel was in peril. Over one hundred people, primarily mariachis, were living in the hotel, many sharing one small room with a bathroom down the hall, a typical urban hotel design of the late 1800s. The exterior retained most of its original historical features, although it was missing its most distinctive element, the cupola. The condition of the interior was abysmal, a result of decades of neglect and an aged infrastructure. Until the late 1990s, when plans got underway for a metro station at Mariachi Plaza—a five-minute ride from downtown L.A.—this Mexican neighborhood on the wrong side of the river had been of no interest to developers. Suddenly the Boyle Hotel was a hot property, not because of its historic value as a distinguished Victorian business block, but for the land beneath it. Miraculously, a series of fortuitous events saved the old Cummings Block and the mariachis from disappearing from Mariachi Plaza.

When I first encountered Mariachi Hotel, I had just begun graduate studies in Historic Preservation and Regionalism at the University of New Mexico in Albuquerque (UNM). After seeing the Cummings Block for the first time, I telephoned the local Los Angeles city councilmember's office to learn the status of the building. They referred me to Diana Ybarra, president of the one-year-old Boyle Heights Historical Society. Diana and I found that we shared a common goal and a common passion: saving the Boyle Hotel-Cummings Block from the wrecker's ball. Meeting Diana was a lucky turn of fate, the first of many. Diana grew up in the neighborhood, cared deeply about its history, and had her finger on the pulse of the community and its politics. Suzanne and I had put together extensive documentation on the early history of the building, which we shared with Diana, who already had gained the support of the Los Angeles Conservancy.

Our first objective was to list the property as a Los Angeles City Historic-Cultural Monument. However, we knew that obtaining this designation would be an uphill battle without the support of the property owner and the local councilmember, which did not appear to be forthcoming. Even if we could save the tangible heritage of the building, I could not envision a scenario that included preserving the intangible heritage of the mariachi musicians. The economy was already on the downswing and we needed an "angel"—fast.

Diana and I focused on the paperwork for the monument nomination even as the streets were rife with reports of developers eyeing the property. As 2006 drew to a close, angels appeared out of the blue. The East Los Angeles Community Corporation (ELACC), an affordable-housing nonprofit, signed a purchase agreement for the Boyle Hotel.

As good fortune would have it, they were committed to preserving the historic character of the building and keeping it a low-income residential hotel for the mariachis. Directors María Cabildo and Evangeline Ordaz-Molina let their hearts guide them when they bought the property. They both knew the area and the building from their childhood, remembering the mariachis gathering at the donut shop. As Evangeline described it,

> The impetus for buying the hotel was both nostalgic and mission driven: for one, ELACC wanted to keep a major community icon in community hands. Not only was the building historic, but the fact that eighty percent of the residents of the building were itinerant mariachi musicians made it culturally valuable and meaningful, too. A church owned the hotel but had gotten into bed with a developer who hoped to turn the building into loft units. This would have displaced the mariachis. We also wanted to improve the slum conditions of the building and preserve it as affordable housing for the musicians and other low-income residents of the community. The building was in deplorable condition and the tenants had filed a lawsuit against the owner over the slum conditions.[31]

I soon learned that María and Evangeline were not the only ones who cared about saving the hotel. By then I had completed my graduate studies and had time to travel to Los Angeles to work on the nomination. The day my husband, John, and I arrived, I read a notice for a community meeting in Boyle Heights. It turned out that ELACC had organized it as an informal focus group to explore what local residents wanted for the future of the old Boyle Hotel. During the bilingual meeting, one person said, "It's a local icon." Then, a woman who had lived nearby all her life stood up and declared, "It's not a local icon. It's *the* local icon." Everyone applauded. This local grassroots attachment to the Cummings Block was a complete surprise to me. This building held the key to awakening and preserving community memory and pride.

Although ELACC purchased the building in order to save it, its future was by no means certain and the fate of the mariachis even less so. Many of the locals, including Latinos, viewed the mariachi community as an impediment to economic growth and rising property values. Rumors abounded about the mariachis and the Boyle Hotel being magnets for drug deals. Although ELACC professed its commitment to the musicians, the mariachis themselves were skeptical. They had been mistreated and misled for decades. There were individuals or groups with ulterior motives who managed to convince some tenants that the new owners were planning to demolish the building and evict them. Certain unknown forces—probably parties who wanted to buy the hotel and develop the valuable property—worked to drum up public support to get the city to condemn ELACC and the building. One of their hatchet men, a hotel resident, went so far as to plant rats in the hallways and throw rocks into the drains to "prove" that ELACC was yet another slumlord. Despite the promise that ELACC brought, the future looked grim.

Fearing the worst, I implored one of my professors, photographer Miguel Gandert, to make one visit to Los Angeles in order to document the hotel and the mariachi musicians for posterity. That one visit turned into many over the course of several years. Miguel was hooked, and so was I. We stood around for days at a time on Mariachi Plaza, Miguel sometimes talking to the musicians, sometimes taking photographs, sometimes recording oral histories in Spanish. Miguel has a way of blending in with whomever he is shooting, even with his necklace of Leicas. I also came to feel like part of the scenery. In time the mariachis came to know and trust us. I grew to respect their professionalism and dignity and to envy their special camaraderie. I also began to identify more and more with my Mexican roots. The music touched me viscerally. The plaintive melodies, the joyous sounds, the words I could barely understand, sang out to me.

Miguel took photographs, and chatted with the musicians and local merchants in Spanish. An economy had grown up organically around the mariachis: the tailor, the music store, the printer, the cafés, and the music school where young boys and girls were just beginning to learn their art. Miguel photographed a couple dancing to the music of the mariachis they had hired to play in the Mariachi Plaza kiosk for their anniversary. Juan, a violinist, invited us to hear his group play at a seventy-fifth birthday party thrown by neighbors for a Salvadoran woman separated from her family. It was a highlight for us. Luisito García had lived in the hotel since the 1960s—longer than any other mariachi. Miguel captured him on film and video. Later that year we joined others in mourning his passing, at the age of eighty-three. Even though I had thought I was having the same experience as Miguel during our many visits to Mariachi Plaza, his photographs proved otherwise. His eyes opened mine, and still do.

Looking ahead, it occurred to me that we would need a website.

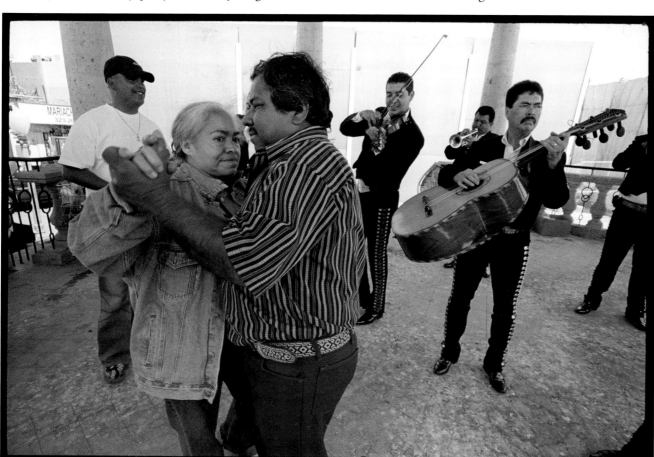

Celebrando la vida /
Celebrating Life

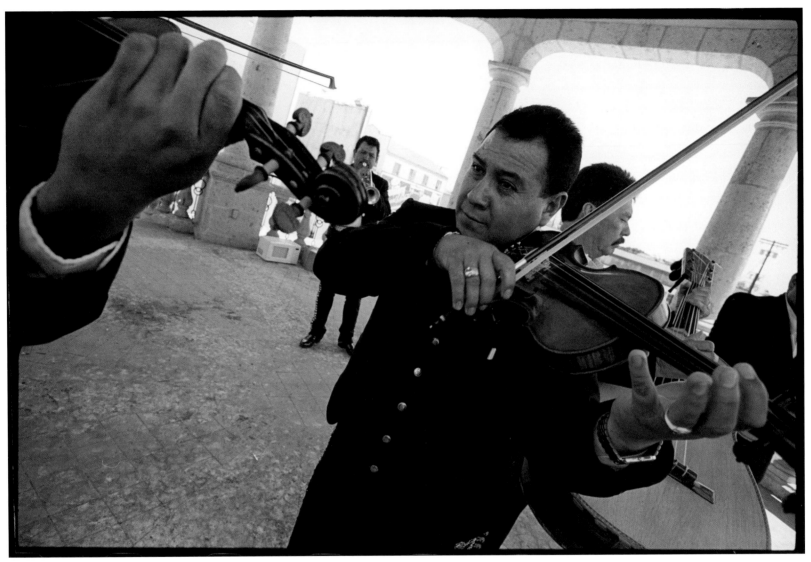

Violines en armonía / Violins in Harmony

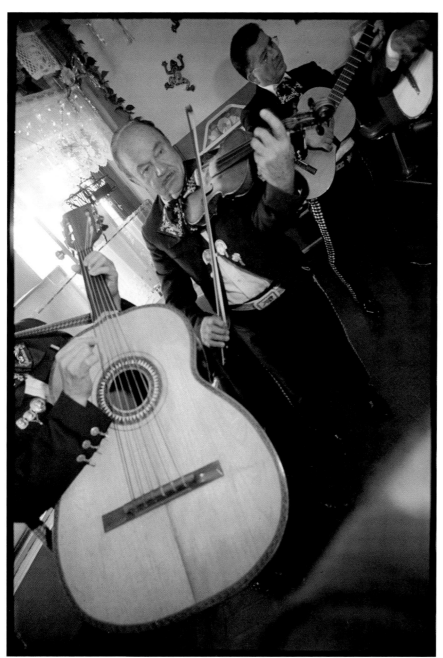

Bajo de trasfondo / Bass in the Background

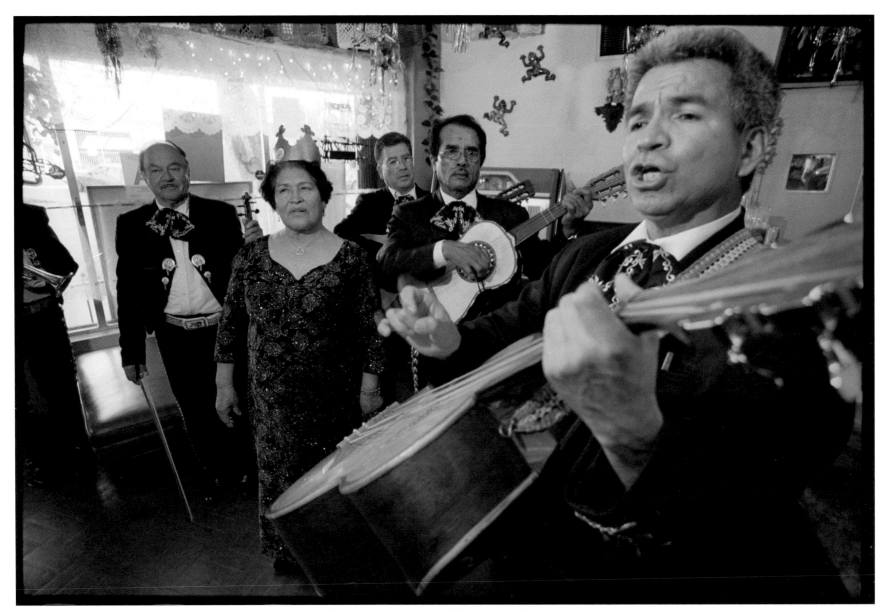

Homenaje a una princesa / Homage to a Princess

Fortunately, "mariachiplazalosangeles.com" was available, and I grabbed it. With the invaluable assistance of Miguel and a computer-whiz student of his, we put together a website to share the joy and struggles of the mariachis on and near the plaza. Our intention was, and still is, to hand over this website to the mariachis themselves.

Miguel, John, and I drove out to Los Angeles for Cinco de Mayo and two other times for Santa Cecilia Day celebrations sponsored by the City of Los Angeles. Every fall the mariachis honor Santa Cecilia on the weekend near her saint's day, November 22. The first year we went it was a relatively small event, but the next one turned out to be a blockbuster complete with a big tent, Councilmember José Huizar, and big-name mariachis from other parts of L.A.

On a Tuesday morning in late November of 2010, Enrique Lamadrid, a close colleague of Miguel's at UNM, joined our next pilgrimage to Los Angeles, this time for an unannounced and unadvertised local celebration of Santa Cecilia Day, unlike the city-sponsored ones that we had attended before. Enrique, Miguel, and I arrived at Mariachi Plaza before dawn for the daylong homage that the local mariachis themselves planned and produced on a shoestring. Enrique's profound understanding of the music and the underlying meaning of the lyrics raised my appreciation to a new level. It was worth the wait to experience the mariachis' own Santa Cecilia celebration with Enrique, who describes it in his essay from the perspective of a poet and folklorist.

The importance of preserving the building and investing in its restoration was clear to me, but I could not be sure that my vision was not colored by my personal attachment, or that the hotel was not too far gone to save. Not long after ELACC purchased the property, I contacted, thanks to references from my professors at UNM, a number of preservation professionals working for local, state, and national organizations. During a preservation conference in Los Angeles, they broke away and came to Boyle Heights to join the ELACC directors, Miguel, and me on a tour of the hotel. To my great relief and joy, the preservationists, without exception, immediately recognized how critical it was

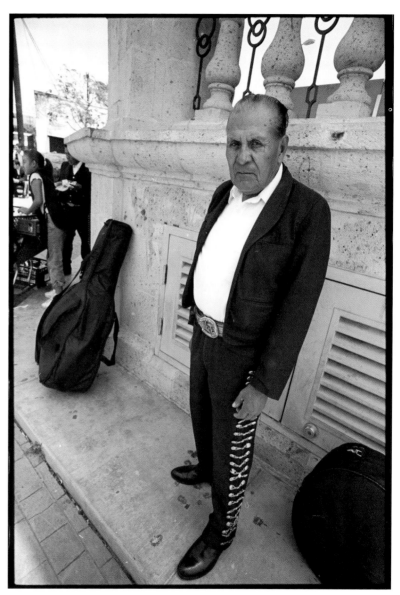

Medio siglo en la plaza / Don Luis: Half a Century on the Plaza

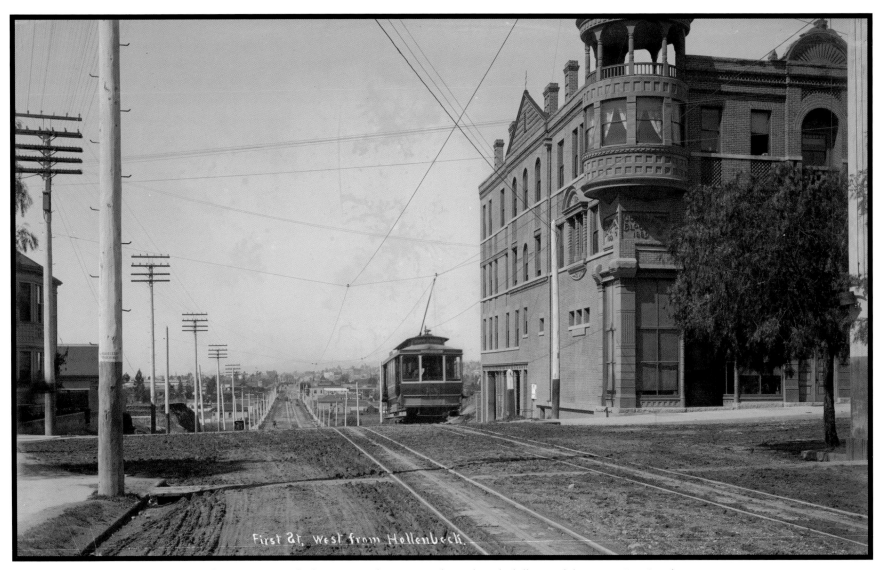

First St. West from Hollenbeck.

View of East First Street looking west with a streetcar descending the hill toward downtown Los Angeles, c. 1895.
William H. Fletcher, photographer. Courtesy of the California History Room, California State Library, Sacramento, California.

to save the old Cummings Block. Amazingly, the building had survived with its basic architectural integrity, its footprint, and its original function as a hotel. The façade of the Romanesque Revival–Queen Anne style building retained many of its most important character-defining features: full-story ground-floor storefronts, cast-iron columns, arched window hoods, the "Cummings Block/1889" lettering, and the ornamental brickwork. The redbrick facing signified the importance and enduring nature of the structure. The corner turret was the signature design element, which could be seen from all directions. The historical significance of the Boyle Hotel-Cummings Block was clear: it is the only extant commercial building in this area from the late 1800s, when Boyle Heights was shedding the last vestiges of Mexican social, political, and financial influence. Its reemergence at this location as a transportation node and Hispanic center provides a vital—and fragile—connection with the cultural and intangible heritage of Boyle Heights and Los Angeles. The early history of the hotel embodies the story of Los Angeles transitioning from a Mexican pueblo to an American commercial center in the last quarter of the nineteenth century.

When Professor Chris Wilson, the director of the Historic Preservation and Regionalism program at the University of New Mexico, was in Los Angeles, he found time to visit Mariachi Plaza. I was thrilled by his response. He wrote a strong letter of support for the historic designation. To launch the massive Boyle Hotel project, ELACC held a fundraising dinner for over five hundred guests in the grand plaza of the Cathedral of Our Lady of the Angels, with twenty-foot projections of Miguel's mariachis on the wall. Mariachi Plaza musicians played the warm-up, and the esteemed Mariachi Los Camperos de Nati Cano were the headliners, donating their time for this cause. I gave a short talk on the hotel's history. We invited Geraldine Forbes Isais, now dean of the School of Architecture and Planning at the University of New Mexico, to sit at our table. She offered a fresh perspective. I came to understand that the Cummings Block was more than a local icon when she recalled how, for many years, the corner brick building with its distinctive turret and cupola had been a landmark for her as well, a sentinel at the gates of the city on her east-west commute from her home in Whittier to downtown Los Angeles.

Local residents and the preservation community worked together to save the old building, despite hostile economic interests. While wealthier areas had rallied to save their heritage, Boyle Heights, one of the city's oldest neighborhoods, never had the political clout or organizational skills to prevent freeways and urban renewal projects from destroying its historic fabric. Against all odds, on October 24, 2007, the City Council voted unanimously to list the Boyle Hotel-Cummings Block as Los Angeles Historic-Cultural Monument number 891.

Much of *Claudio and Anita* was based on fact. Verifying the story of Claudio López unearthed a goldmine of information about him and the extended López family. It also shed light on the mixed-caste pobladores who founded the pueblo of Los Angeles and on the complex history of Los Angeles during the Mexican period and the second half of the nineteenth century after the Anglo takeover, when California's Hispanic culture was under siege. It seems that my grandparents and others of their generation were conflicted about their Hispanic roots. While they embraced their Spanish and Californio heritage, they distanced themselves from their more recent Mexican American history. They were fiercely proud of their Spanish ancestry from the López line, who had settled in Los Angeles at the end of the eighteenth century as part of what Los Angeles historian William Estrada calls the "second wave of pobladores," whose descendants were Californios, disconnected in time and space from Mexico.[32] In the early twentieth century and even before, my family, like others, was seduced by the romanticization of California's Spanish fantasy heritage, At that time the Spanish past was idealized by Latinos and Anglos alike, as exhibited in the vogue for the Spanish Colonial Revival in architecture, film, and other forms of popular culture.

My mother's grandmothers were Hispanic: Sacramenta López and Dolores Serrano (the latter's family having moved from Hermosillo to Tucson in the 1850s). Both Sacramenta and Dolores had lived with my mother's family for a time. I cannot help but wonder what the grandmothers shared or did not share with their grandchildren. I do know that my bilingual grandparents went out of their way not to speak Spanish with their children. My mother knew only a few expressions, which came out during moments of stress: "¡Dios mío, por mi vida!"[33] She thought her name was Kathleen until she applied for a passport in her thirties and discovered that it was Dolores Lolita. Aunt Dorothy never knew that hers was Consuelo. Why? I suspect that it was not easy growing up in southern California during the xenophobia of the 1920s and 1930s, when anti-Mexican sentiment was at a fever pitch.

Thanks to the Boyle Hotel and Mariachi Plaza, I have lifted the Spanish veil that obscured my mestizo ancestry. When I followed the mariachi up the stairs that Sunday morning in April 2003, I opened a metaphorical door to my Mexican past—and present. For others as well, this old brick-and-mortar building connects the time when this *was* Mexico with today, when it is home again to Mexicans, including the largest concentration of mariachis in the United States. Some of them are residents of the newly renovated and historic Boyle Hotel-Cummings Block on Mariachi Plaza de Los Angeles. Their music is a gift that reaches all Mexicans wherever we are.

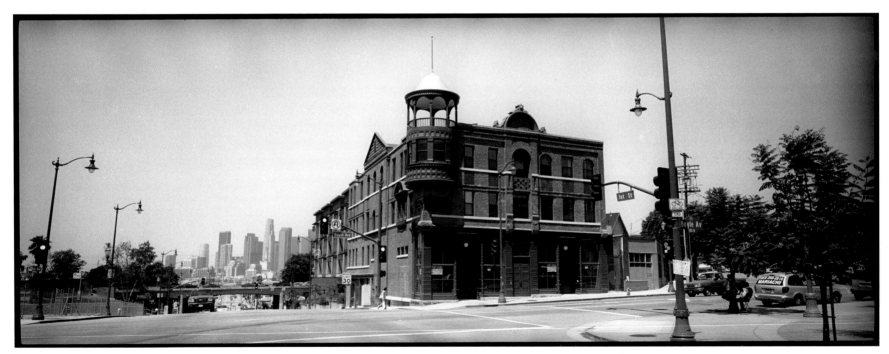

De nuevo, nuestro hotel / Our Hotel Renewed. The Boyle Hotel-Cummings Block, 2012.
Following major restoration, it is again the proud anchor of Mariachi Plaza de Los Angeles.

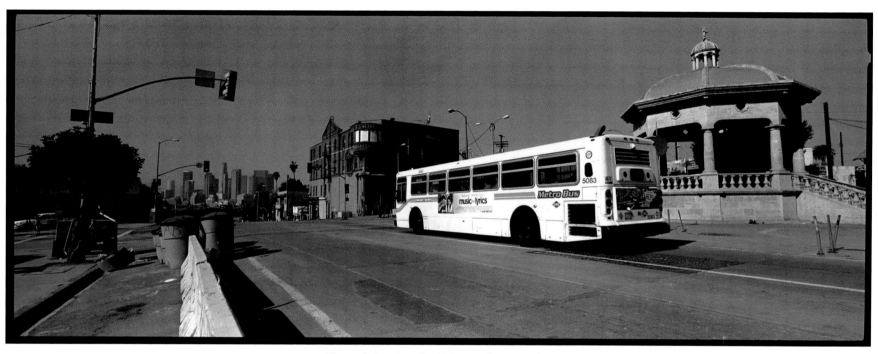

Torres de Los Angeles / Towers of Los Angeles

Esquina musical /
Musical Corner

Albergue mariachero /
Refuge of Mariachis

Papel volando / Paper in Flight

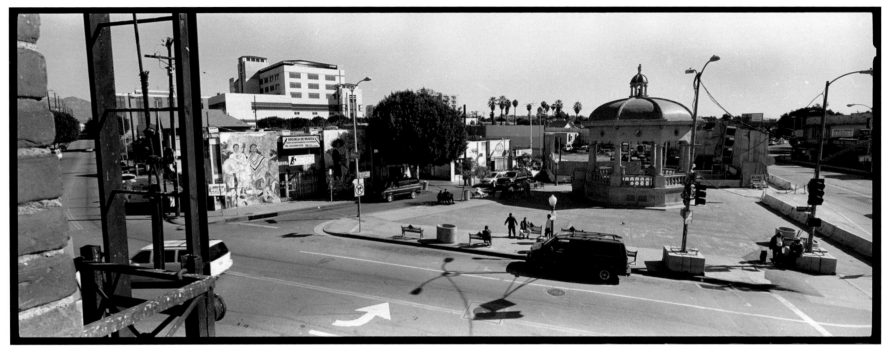

Plaza casi vacía / Almost Empty Plaza

Hotel de los Mariachis /
Mariachi Hotel

Las llaves de mi cuarto /
Keys to My Room

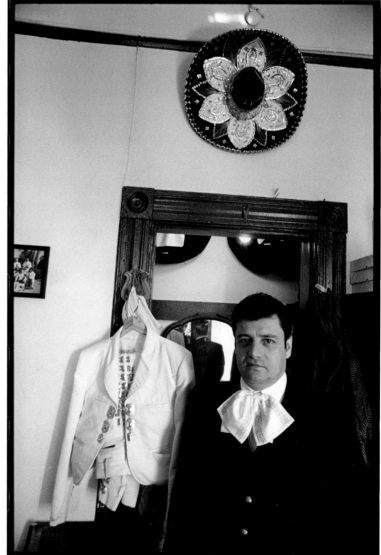

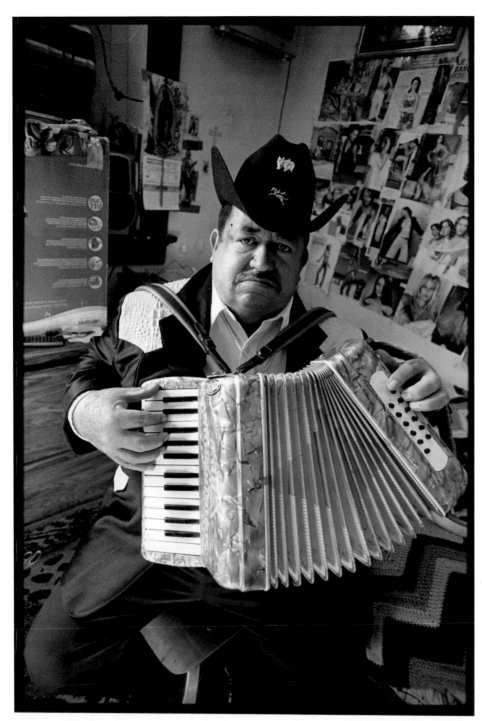

También los norteños / Northerners Do It Too

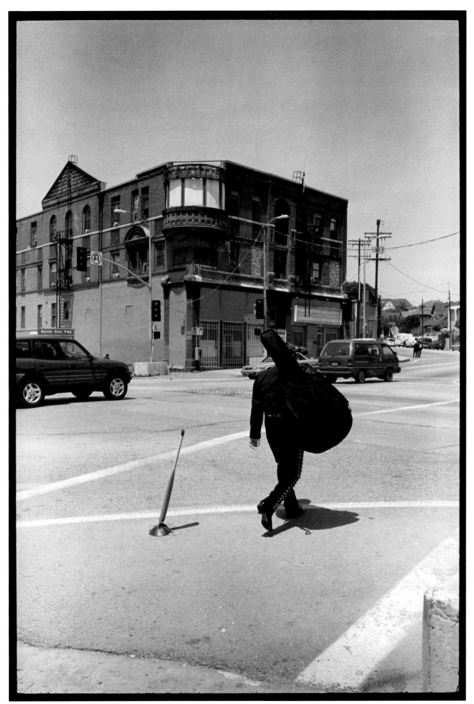

Carga angelical / Cargo of Angels

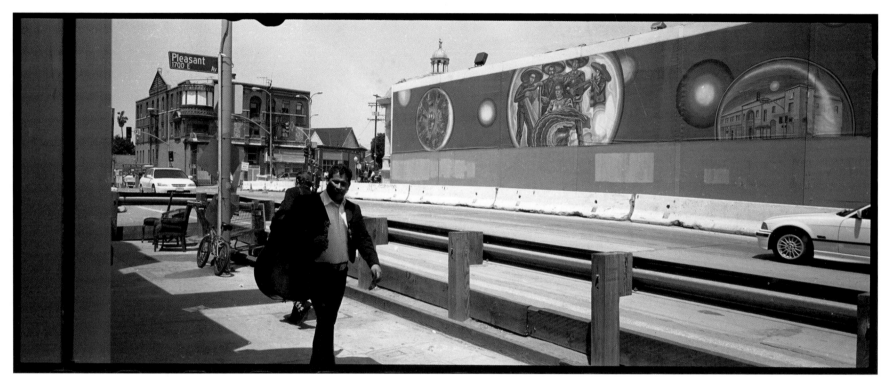

Viene el Metro / The Metro Is Coming

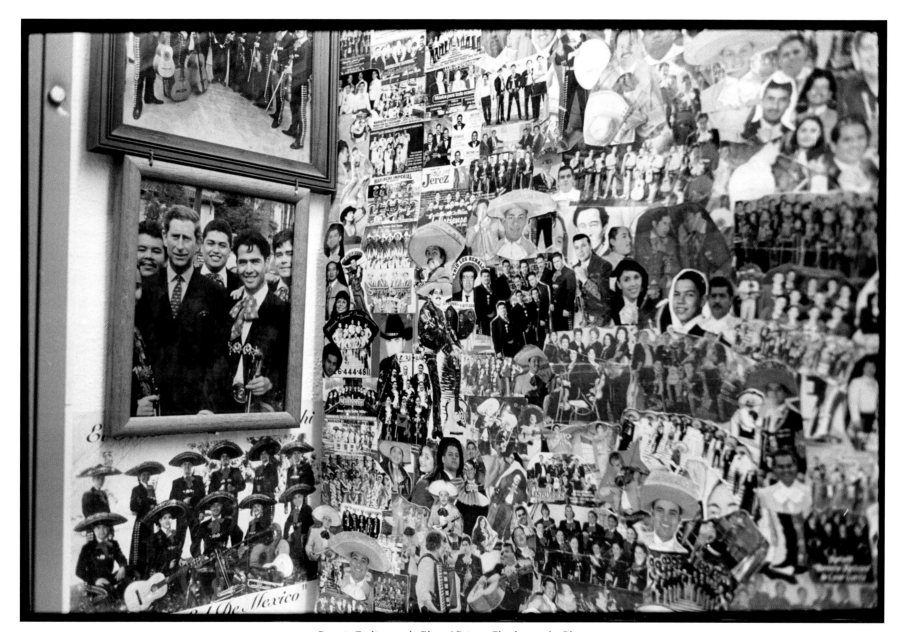

Bonnie Carlitos en la Plaza / Prince Charles on the Plaza

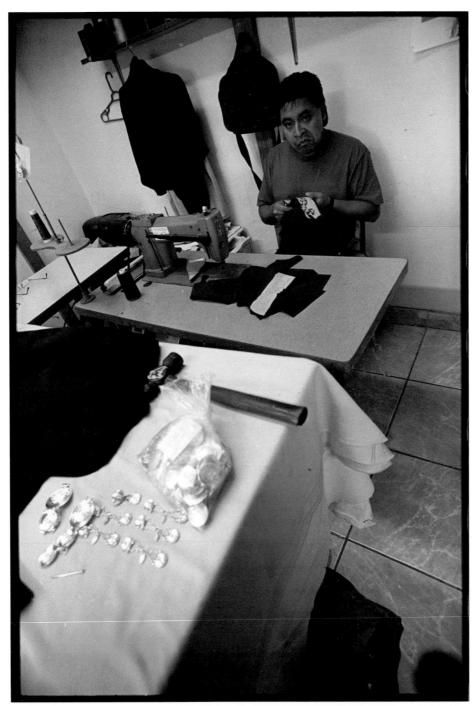

Lana y plata / Wool and Silver

Bicicleta mariachera / Mariachi Bicycle

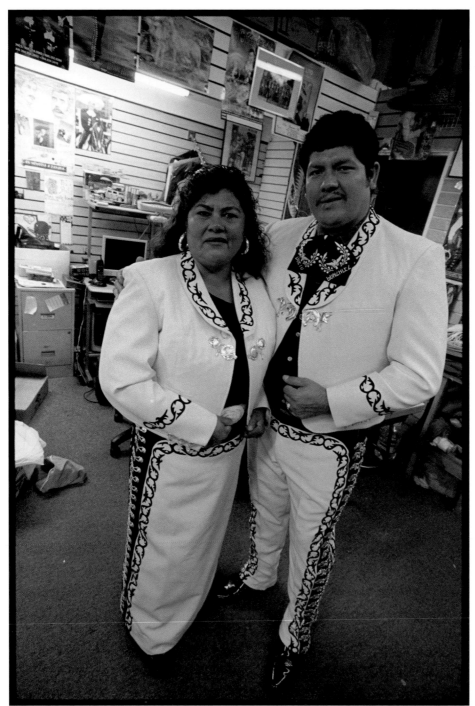

Pareja de plata / Couple in Silver

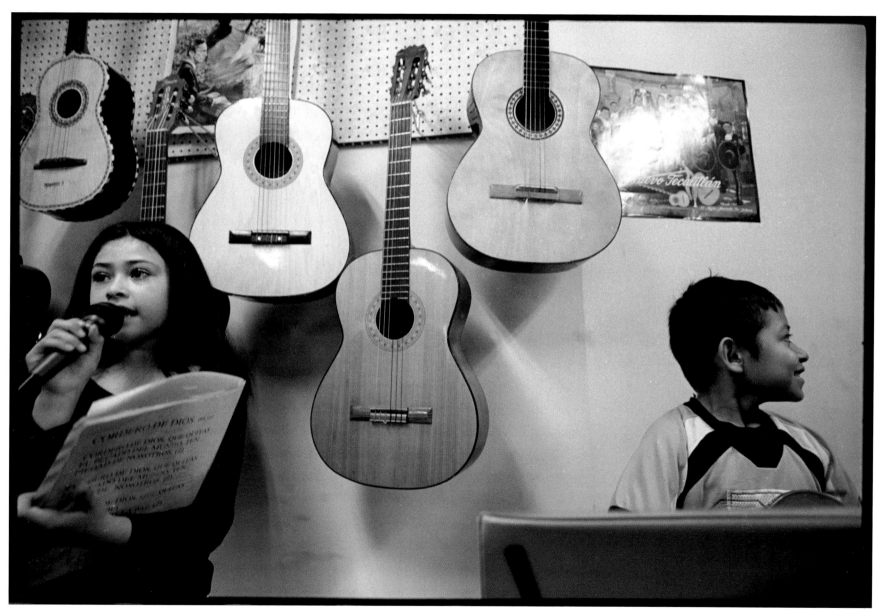

Aprendiendo la misa / Learning the Mass

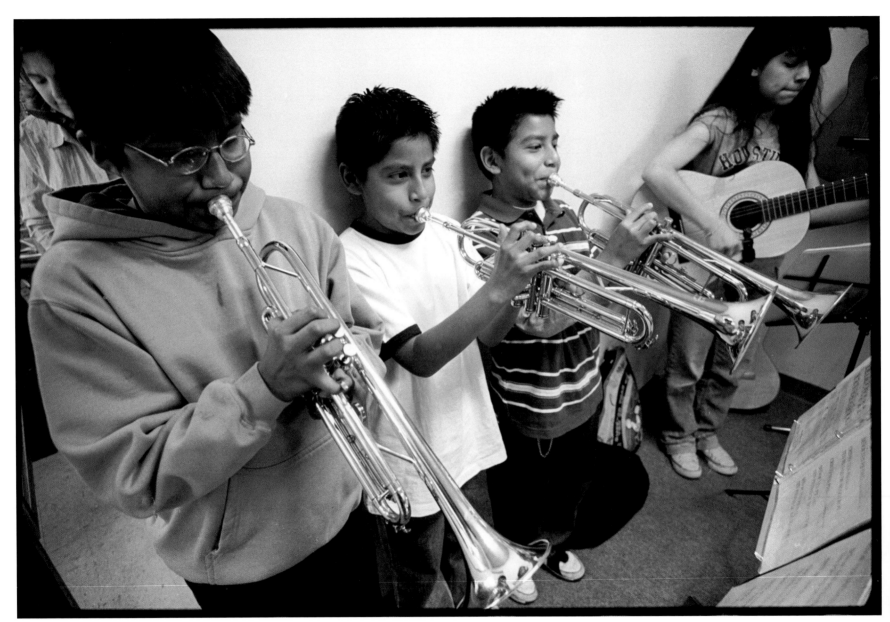

Se aprende tocando / You Learn by Playing

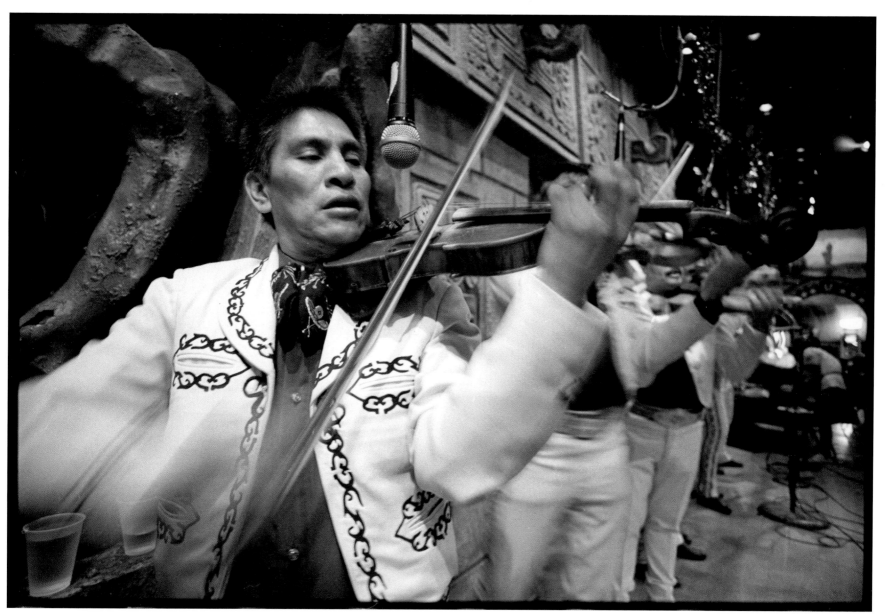

Al pie de la pirámide / At the Foot of the Pyramid

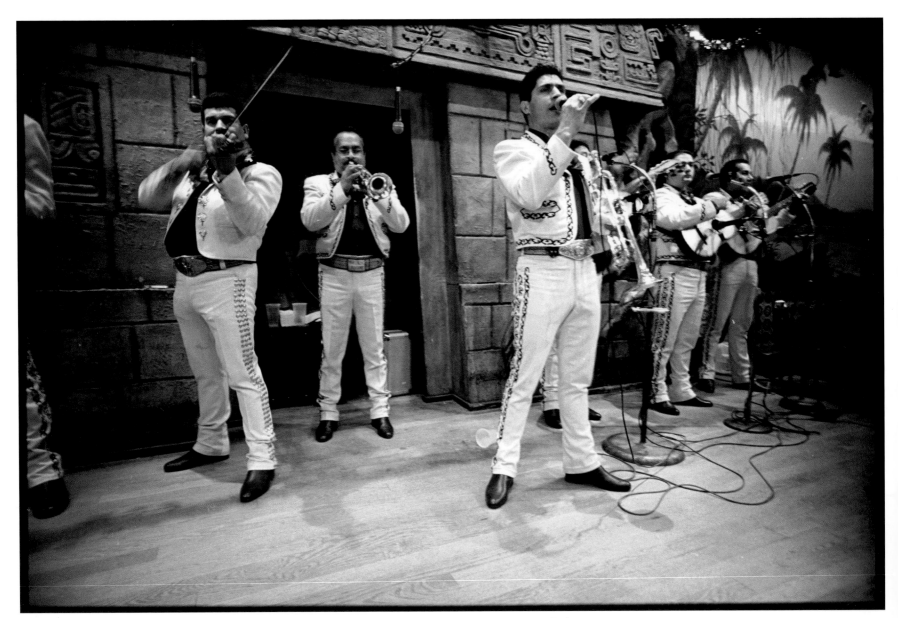

Himno a un dios maya / Hymn to a Mayan God

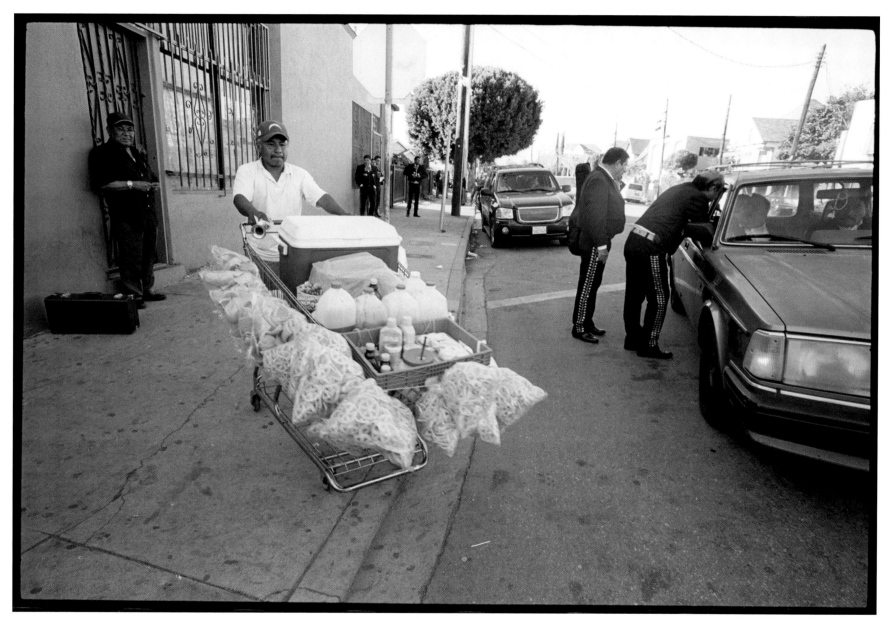

Chicharrones y refrescos / Cracklings and Sodas

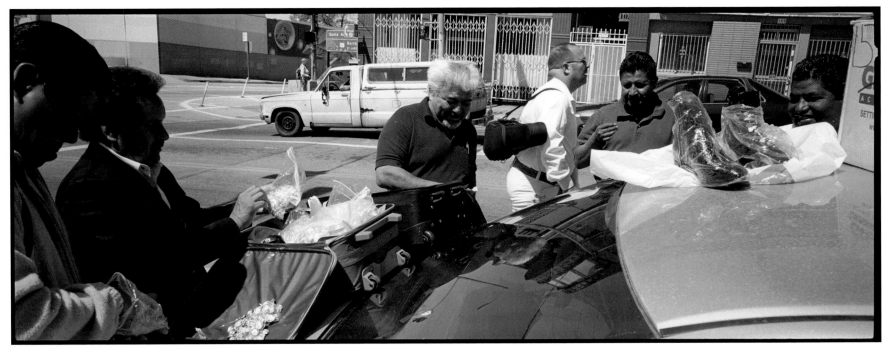

Botas y botones / Boots and Buttons on the Plaza

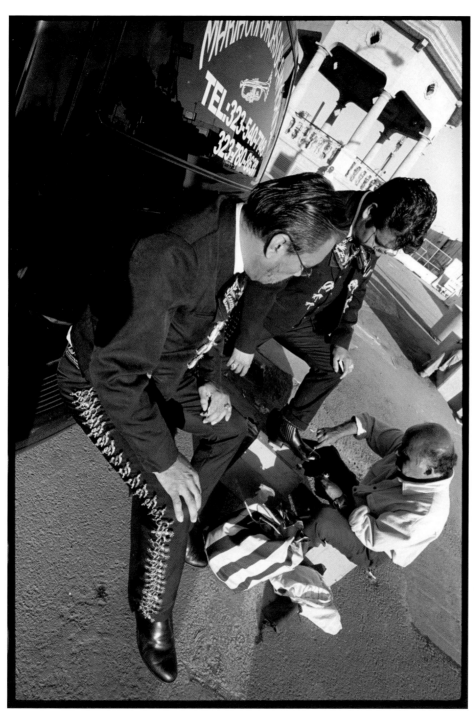

Alma de charol / Soul of Patent Leather

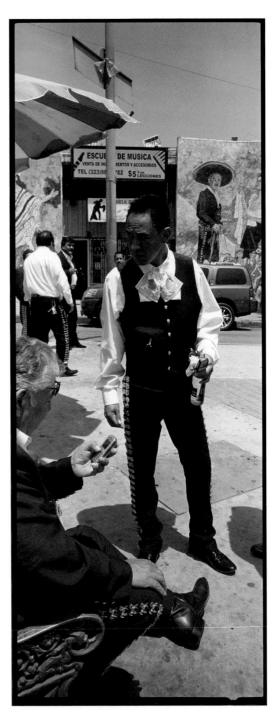

Trabajando el celular / Working the Cell Phone

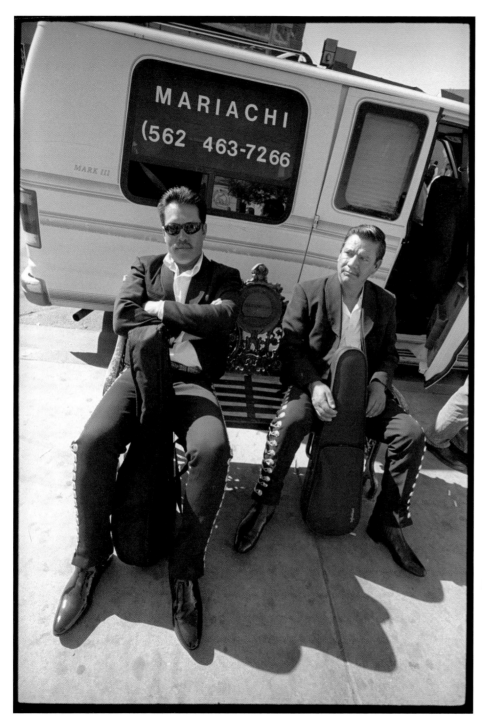

Mariachi al talón / Mariachi for Hire

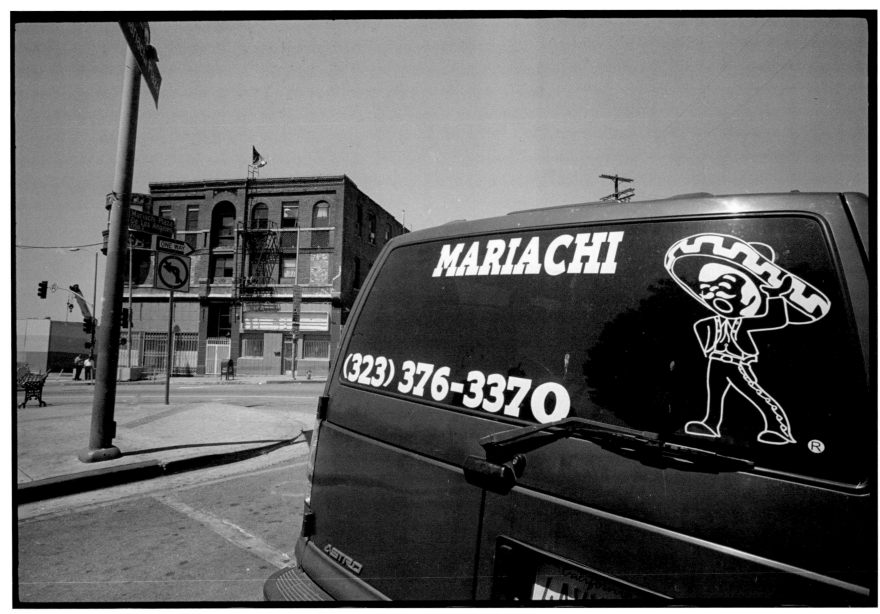

Mariachi-to-go / Mariachi-to-go

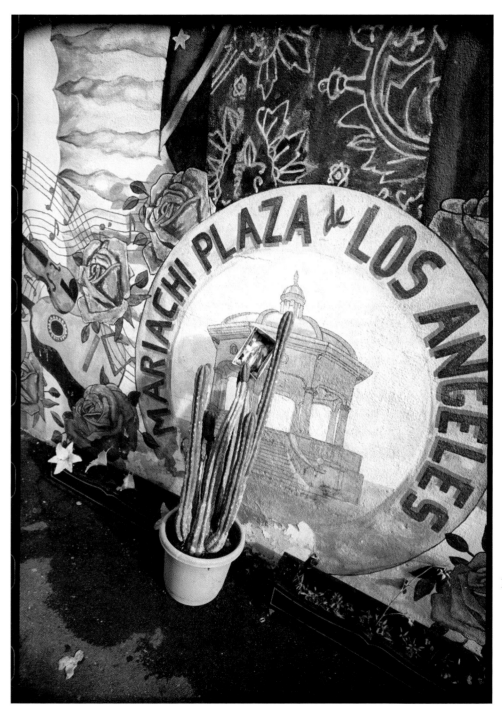

Logotipo de la Plaza / Mariachi Plaza Logo

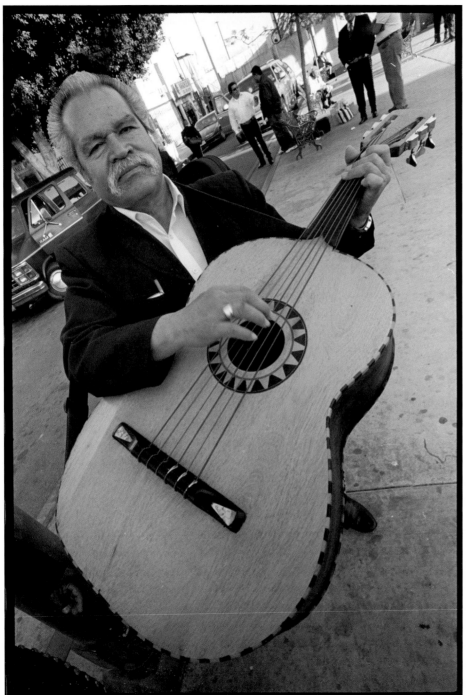

Guitarronero / Guitarrón Player

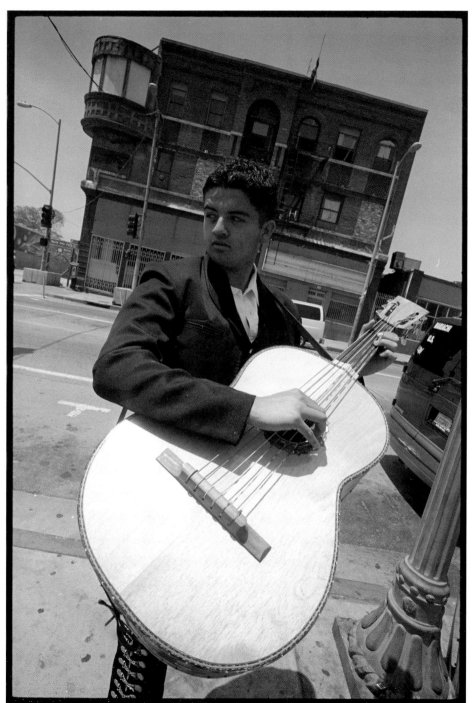

Ambiciones relumbrantes / Shining Ambitions

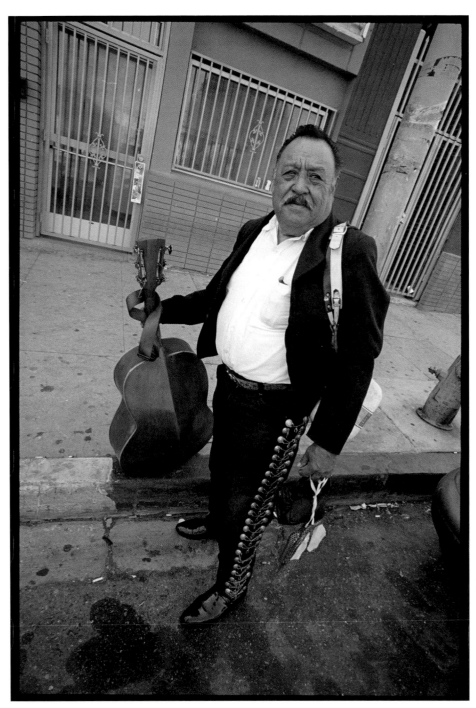

Maestro del corazón / Master of the Heart

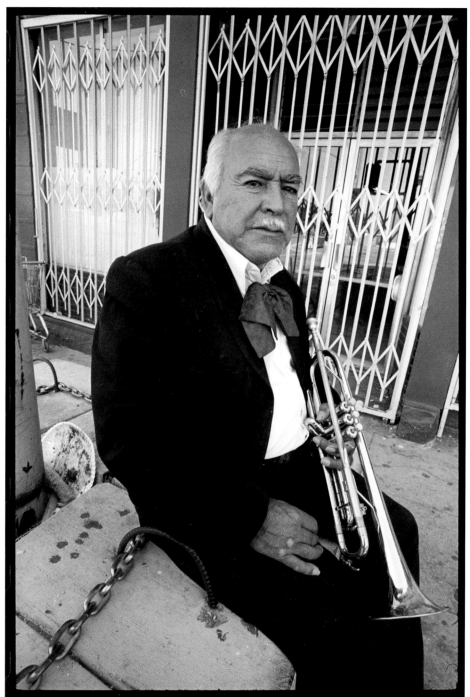

Todo un caballero / Every Bit a Gentleman

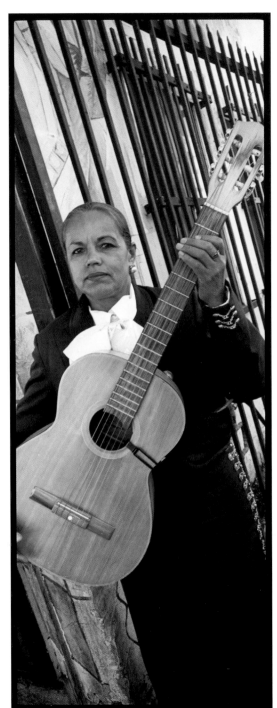

Para mi tío Agustín / For My Uncle Agustín

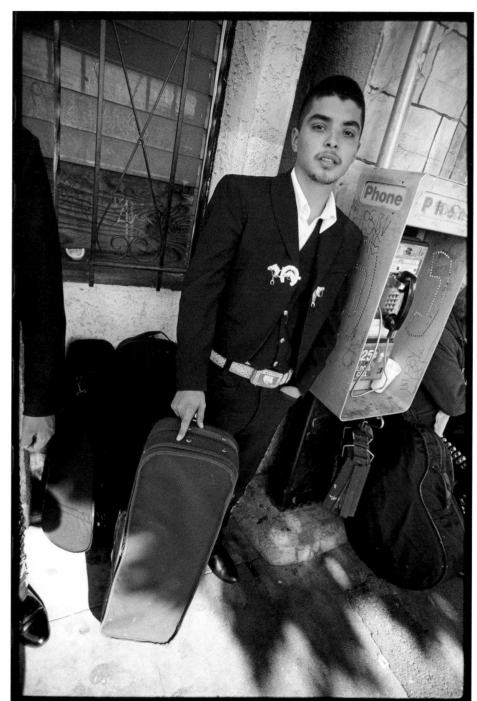

Esperando la llamada / Waiting for the Call

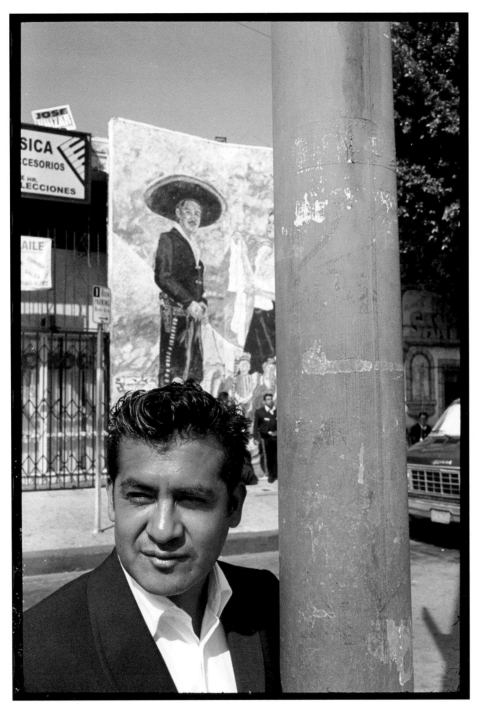

Sueños sublimes / Sublime Dreams

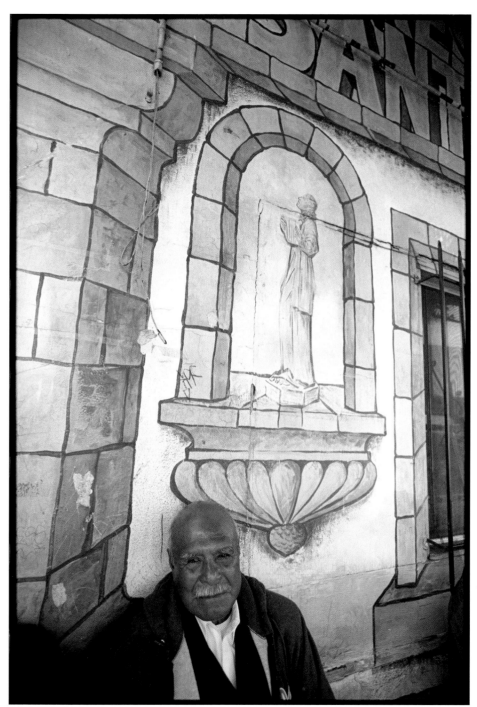

Alma de cantera / Soul of Quarry Stone

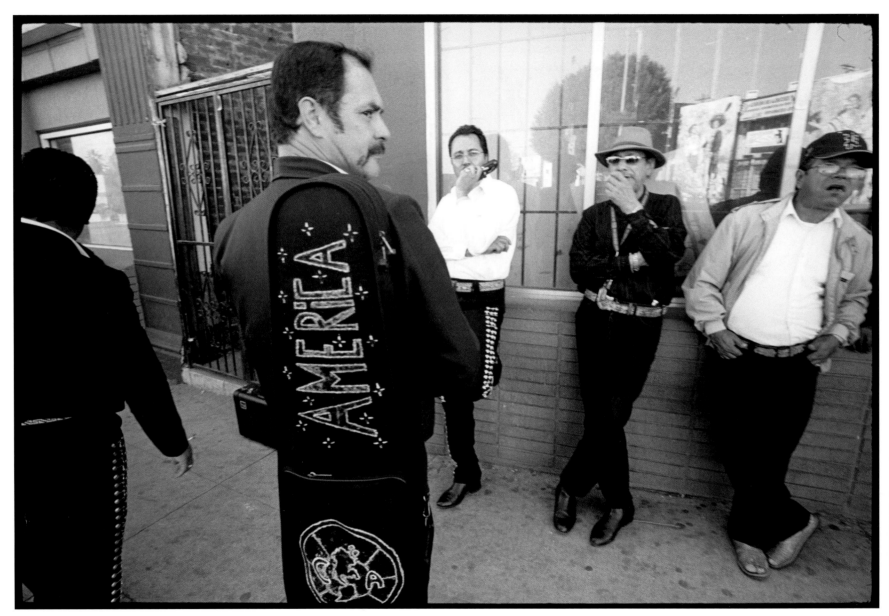

América presente / America Is Present

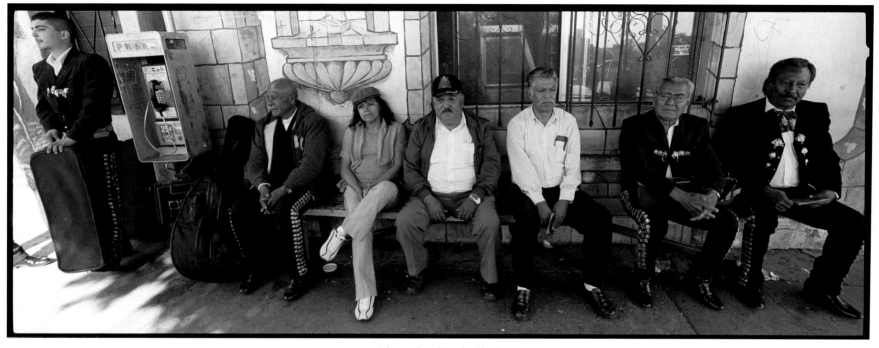

A la sombra / In the Shade

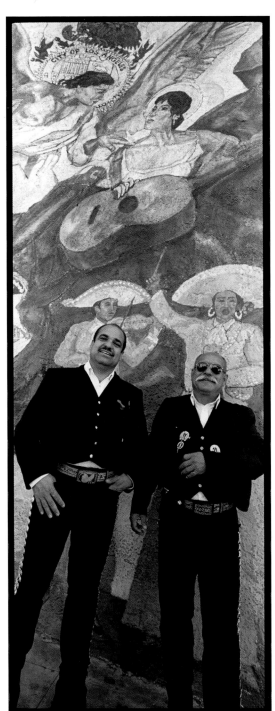

Alma de Los Angeles / Soul of Los Angeles

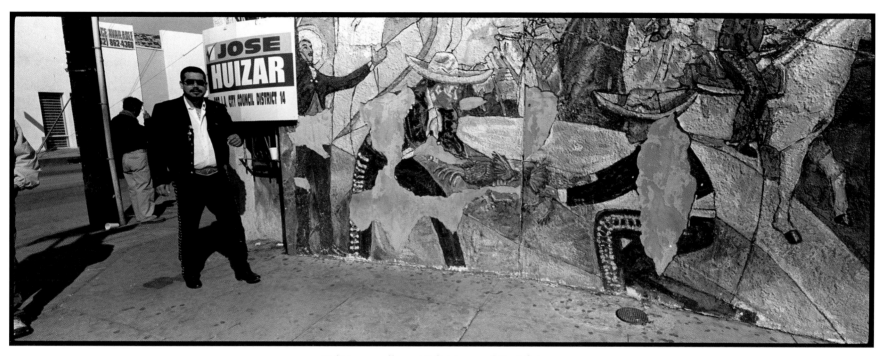

Políticos y galleros / Politicians and Cockfighters

Glorieta tapatía / Bandstand from Jalisco

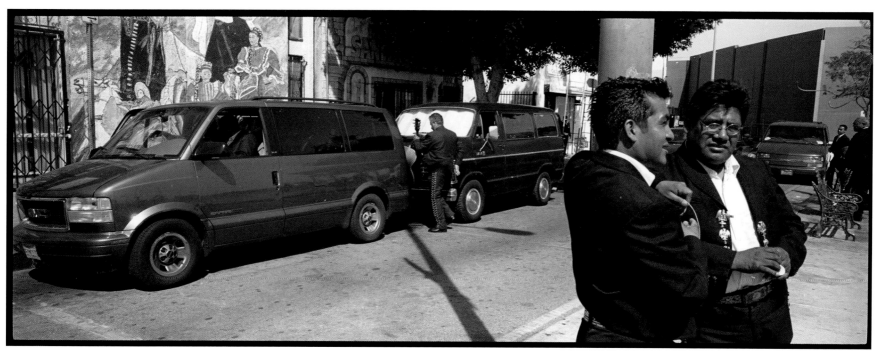

Mitoteando en la plaza / Gossiping in the Plaza

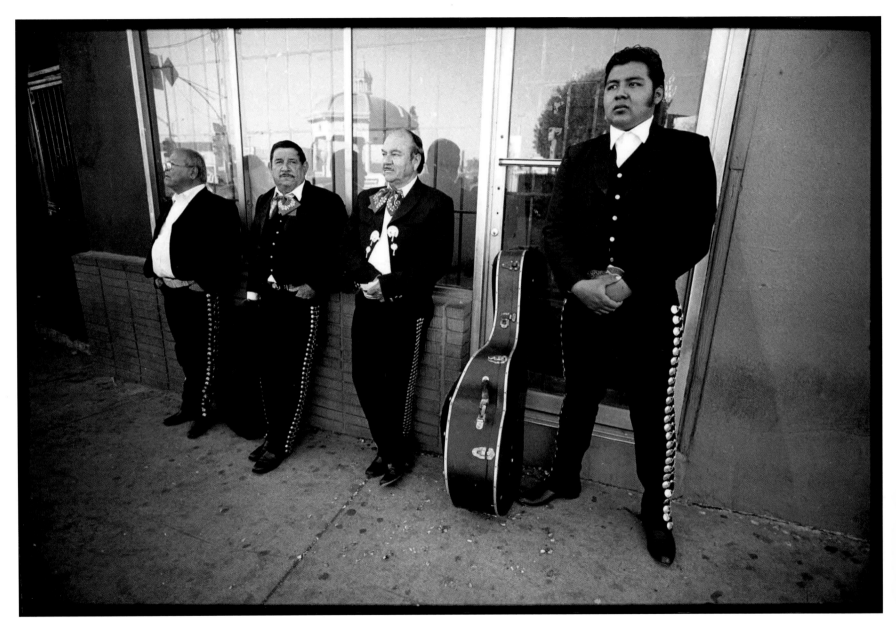

Reflexiones / Reflections

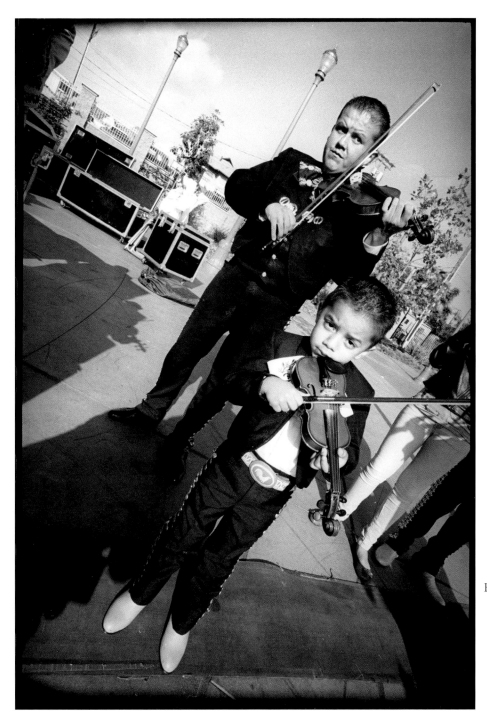

El violín más pequeño / The Smallest Violin

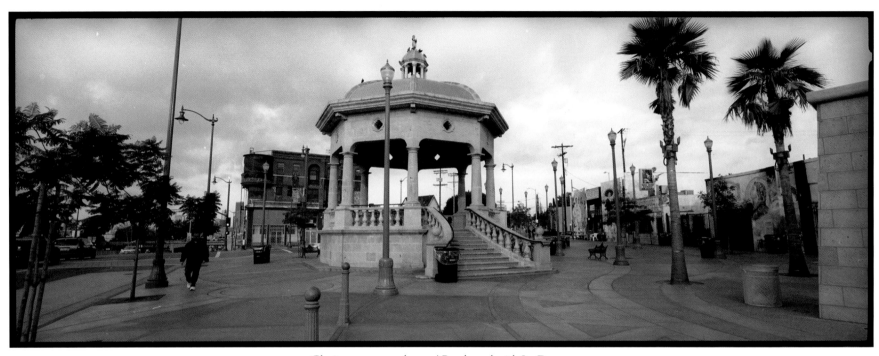

Glorieta con sus palomas / Bandstand with Its Doves

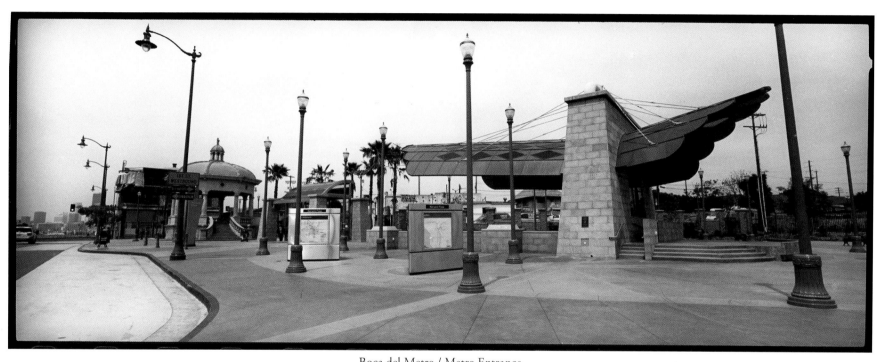

Boca del Metro / Metro Entrance

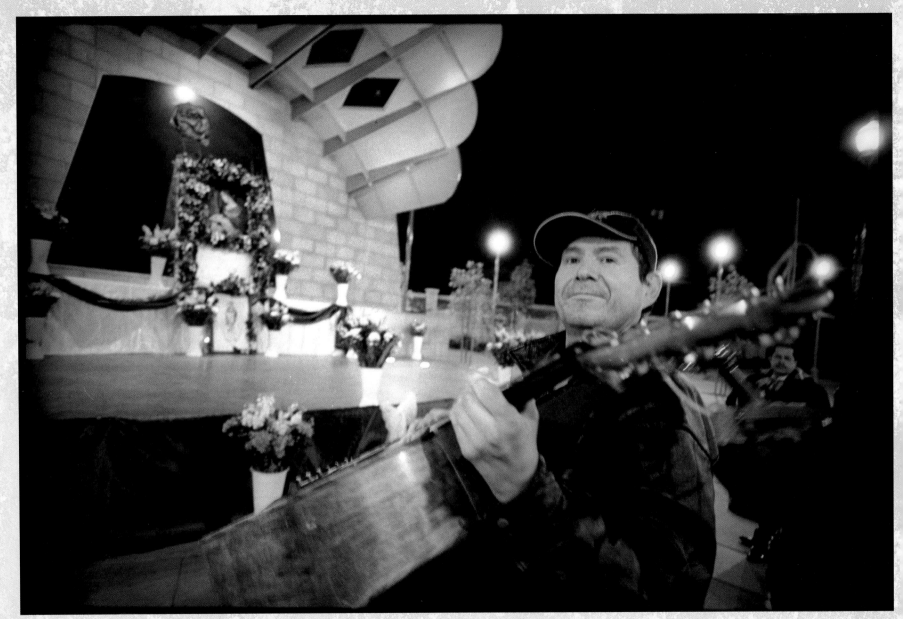

Madrugador y su patrona / Early Riser and His Patroness

A Paean to Santa Cecilia, Her Fiesta, and Her Mariachis

Mariachi Plaza/Pueblo de Nuestra Señora de los Ángeles
Alta California, Greater México/U.S.A.

ENRIQUE R. LAMADRID

Two hours before dawn, a chill November breeze blows down the concrete channel of the Río de los Ángeles and east across the sandstone bluffs the people used to call Paredón Blanco to Mariachi Plaza, at the corner of First Street and Boyle Avenue in Boyle Heights, the first blocks of East L.A. A lone musician sits on a wrought-iron bench warming up with a cup of chocolate, embracing his *vihuela*, his chubby little rhythm guitar, which he has wrapped in a blanket. Soon we will all sing "Las mañanitas," the little Mexican morning song, King David's song in honor of love and light and music to celebrate birthdays and saints' days, anniversaries and inaugurations. Full of celestial references to moon, stars, and sun, the verses fill with special poignancy when sung outdoors at first light. Above, an almost full moon and several faint constellations compete with the lights of downtown Los Angeles in the valley below, sparkling like a giant electric geode cracked open in the night.

A dozen casually dressed musicians arrive on cue, hugging their *violines*, *trompetas*, *guitarras*, vihuelas, and bulging *guitarrón*. The trumpet players blow warm breath through their instruments to wake them up. Suddenly the music begins and we sing: "¡Qué linda está la mañana!" in admiration of the beauty of the morning. There is no audience this early, no tourists at all. Everyone sings to salute Santa Cecilia, the third-century Roman saint who sang the praises of the Lord even as she was being put to death. For today is the birthday of music itself, especially the music of the mariachis! Then we sing "En tu día," the other Mexican birthday song about your special day. Certain verses echo with even more resonance as singing women approach the altar and portrait of the virgin saint with offerings of white and purple flowers:

Hoy Los Ángeles cantan en coro	Today the Angels sing in chorus
por los años que vas a cumplir.	for the years that you have lived.[1]

Mariachi music has been played and sung in Los Angeles as long as it has been celebrated anywhere else in Mexico. What was to become the greatest metropolis in Alta California was founded in 1781 by a group of mixed-caste families from northwest Mexico and named to honor the Queen of the Angels at Porciúncula, Italy, the tiny chapel and "parcel" where Saint Francis founded his order. With them came the multicultural music and dance of the fandango, which evolved over the next century through wars and invasions, new borders, a railroad, industrialization, and new economies into the international mariachi music we know and love today.

Mariachi vocabulary is as diverse as the people who play and listen to it. Used as predecessor and synonym of mariachi, "fandango" is a word as African in origin as its complex rhythms. Nineteenth-century writers claimed "mariachi" as an adaptation of the French word *mariage* and as a symbol of the imperial marriage of French and Mexican cultures. But scholarship has proven that the term was in common use decades before the French Intervention of 1861–1867. As inevitably happens in discussions of Mexican culture, the Eurocentric is challenged by the indigenous. Some scholars think that mariachi, or its archaic form *mariache*, is a word of Cora Indian origin, since it appears as a place name in several old settlements on Mexico's Pacific coast. Mariachi is most probably neither French nor Indian, but mestizo. It has many facets and refers to the space in which festival happens, the musical group that plays there, and, of course their music and instruments.[2]

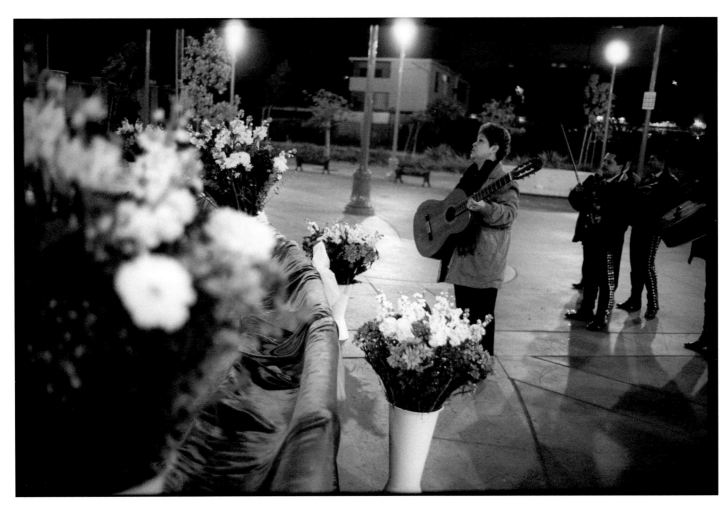

Mañanitas para Santa Cecilia / Morning Songs for Saint Cecilia

Mariachi has always been music in motion, constantly en route from region to region and from the countryside to the cities. Up from the torrid tropical lowlands, the *tierras calientes* of Mexico's Pacific coast, came the *sones abajeños*, literally the songs from down below, with the mule trains and *arrieros* or colorful mule drivers. The catchy tempo and upbeat music brought joy and celebration to the sobering heights of the sierras of Jalisco and Michoacán. Even the armies of imperial France, a Hapsburg emperor, and his wife were seduced by the violins, harps, and guitars in western Mexico. The wind and brass instruments of their military bands were immediately appropriated by the same people who fought the invading armies. In Mexico City, Emperor Maximiliano's castle in Chapultepec was illuminated for grand balls, like a beacon for all the latest European fads—the

scandalous new waltzes and polkas and schottisches with dancers embracing and spinning across the marble halls. As Benito Juárez and the legitimate government fled north, they held legendary soirées and parties in each town and city, capturing the vigor of the same *valses*, *polcas*, and *chotices* for the Republican cause. When the victorious Juárez and his liberals brought reform and modernization, urbanization became their handmaiden, and the music of the people followed them as they migrated to the cities. Mariachis helped with urban adjustment by adding all the new styles to their traditional repertory while also expressing nostalgia for an idealized rural life that had never really been.

Like the music, the emblematic silver-studded costume of the mariachis is a compendium of the same history. The tightly tailored fancy trousers of wealthy ranchers, expandable for use on horseback, were

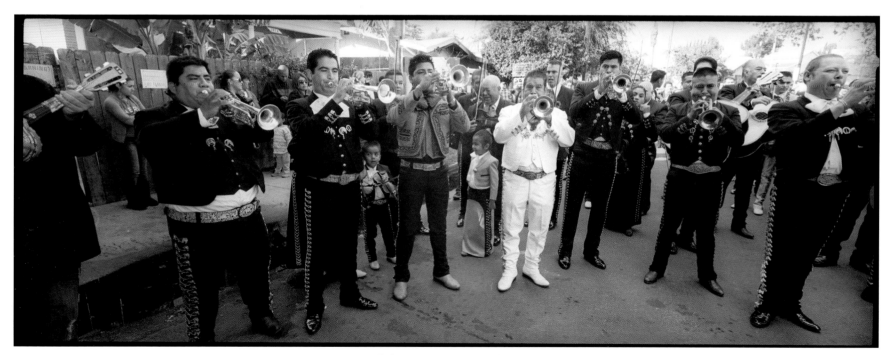

Coro de los vientos / Chorus of the Wind

fitted with rows of silver buttons. Maximiliano created a sensation when he donned the costume sewn with fine black cloth, the color traditionally designated for Spanish royalty. In the chaos following the French invasion, bands of roving bandits were nicknamed the *plateados*, for all the *plata* or silver that they stole and then festooned on their horses, jackets, pants, and broad hats. As many of them joined the liberal cause, the same costume became the trademark of the *chinacos*, the Mexican resistance fighters. Later in the nineteenth century the rural police used the style as the model for their uniform. Now it is the dress of the *charros*, those fancy Mexican cowboys whose rodeo associations issued protests when the mariachis started adopting their dress.

Originally the mariachis dressed much less pretentiously. Since most were *campesinos*, country folk, they typically dressed in *manta*—plain white cotton cloth. When Porfirio Díaz invited Ciro Marmolejo's Mariachi Coculense to Mexico City in the fall of 1905 to play for his birthday and Independence Day, they were dressed in *calzones de manta y huaraches*—the modest white pants and sandals of the peasant. After the revolution of 1910 that ended the dictatorship of Díaz, the revolutionary government also embraced the mariachi in its cultural programs. Decades later, when the same Mariachi Coculense traveled to Chicago in 1933 to represent Mexico at the great World's Fair, they were still dressed as campesinos. The next year when they accompanied Lázaro Cárdenas on his presidential campaign, they traded peasant clothes for fancier trappings.[3] In a country with sharp class and ethnic divisions, for mariachi music to represent the nation, the new gala mariachi uniforms would earn them respect and bridge the gaps between the poor and rich, country and city. Mariachis are truly the musical troops who have conquered the heart of the nation.

In the city, Mexico's romantic *música ranchera*, country music, was born as a modern serenade to a common place so ancient it has a Latin name—*beatus ille*, literally "blessed is he," who enjoys the good life of the countryside, far from the bustle and corruption of the city. Mariachis are the root and accompaniment of this country music and a symbol of an emerging nation. They play for the inauguration of governors, ambassadors, cardinals, and presidents. They are also present for every personal rite of passage—baptism, coming of age, marriage, and death. The deepest verses of "Las mañanitas," whose words we tend to forget, are forever on the lips of the mariachis. The music symbolically flies to the city from all four directions on the wings of doves:

Volaron cuatro palomas	Four doves flew
por toditas las ciudades.	through all the cities.
Hoy por ser día de tu santo	Since today is your saint's day
te deseamos felicidades.	we wish you happiness.

Eminent Mexicano music historian Álvaro Ochoa Serrano likes to say that the national music of Mexico is the "daughter of three cultures"—the people who came here, from Europe—the people who were brought here, from Africa—and the people who were already here, the Native Americans.[4] The beating mestizo heart of mariachi music is the *son*, which draws its polyrhythms from Africa, its Spanish lyrics and instruments from Europe, and its intimate association with dance from the very soil of Mexico. Archaeological evidence as well as colonial chronicles document the use of large foot drums. Some are hollowed logs or wooden platforms; others have trenched sound chambers covered with large planks. This percussion instrument is also the dance platform for the *zapateado*, the dance named for shoes, the fancy footwork step dancing that blends Mesoamerican and Andalusian traditions. The choreography of Native *mitote*, ritual dance, incorporated imitations of animals as well. It is easy to see the graceful strutting and ruffled feathers of *palomas* and *palomos*, mating doves, in *jarabe* dances of the mariachis, the "sweet as syrup" dances whose music and lyrics also evoke *gavilanes*, the hawks that prey on them.

The core of the *son* is the ambivalence between the twos and threes of its syncopated rhythm, which inspires youthful human

bodies into swirling movement and drives aging bodies to at least tap their feet. If you can tap your feet to twos and/or threes in the same tune, it is a *son*. The intertwining rhythm itself is mestizo and symbolic, like an internal corporeal dialogue between the Holy Trinity and the Four Sacred Directions.

Back on Mariachi Plaza, the first early morning *son* on November 23, 2010, is dutifully dedicated to Santa Cecilia at the mañanitas, the dawn initiation of her feast. "La Cecilia" is a classic *huapango*, a Huastecan *son* with characteristic double-stopped violin and falsetto flourishes, which evoke the cultural and natural region of the

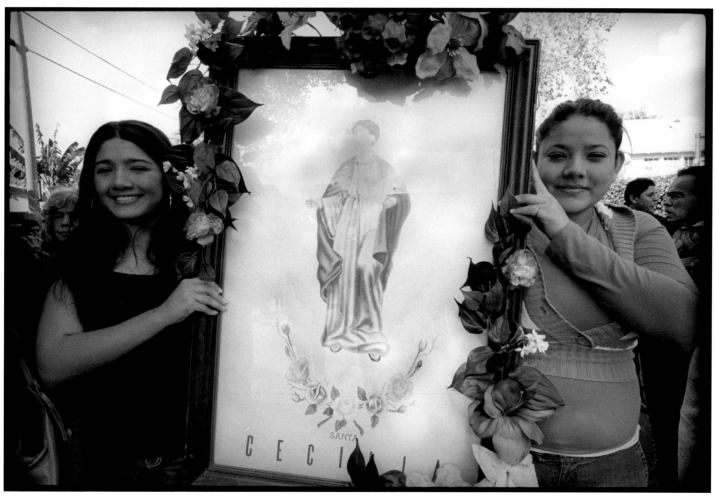

Siempre joven / Always Young

Huasteca, the eastern Sierra Madres and their thick tropical forests and valleys. The mariachis gather around the altar with reverence, as all eyes contemplate the altar and the portrait of Cecilia playing her organ. But this is no hymn. It is a highly eroticized declaration of love for "La Cecilia," an alluring woman of flesh and blood:

Because of the devotion to music of her heavenly counterpart, the praise of the earthly Cecilia is also an allegory of the creative process and the supplication of the poet who is desperate to find the inspiration to finish the poem. This is why composers light candles to their patron saint. The divine Santa Cecilia is a kind of Christian muse who must be invoked, or chastely seduced.

Cecilia, lindo amorcito,	Cecilia, beautiful little love,
te adoro con devoción.	I adore you with devotion.
Quisiera darte un besito	I want to give you a little kiss
con fuego de mi pasión	with the fire of my passion
y estar muy arrecostadito,	and be curled right up
juntito a tu corazón.	right up next to your heart.

Eres un ángel, criatura,	You are an angel, child,
con esos divinos ojos,	with those divine eyes,
y esas cejas tan oscuras.	and those eyebrows so dark.
eres un ángel, criatura,	You are an angel, child,
y ese par de labios rojos,	and that pair of red lips,
que cubren tu dentadura.	that cover your teeth.

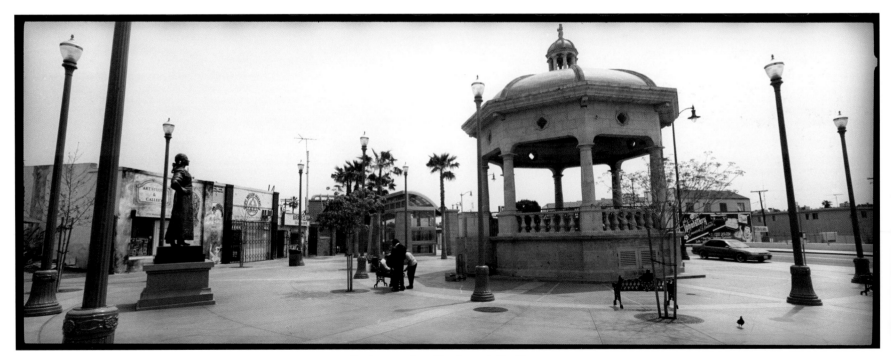

Lucha y su plaza / Lucha and Her Plaza

Nicandro Castillo is the poet who composed these verses, which were made famous by the great ranchera singer Miguel Aceves Mejía in the 1940s and 1950s. Did Castillo know the story of Santa Cecilia and her wedding night? Or did he somehow intuit it? The beautiful Roman woman was born to a patrician Christian family who betrothed her to a young pagan nobleman, Valeriano. On her wedding bed she convinced him that an angel guarded her virgin body and that he should meet the angel. He did, converted to Christianity, and was soon martyred not long before his lovely wife was in the year AD 230. The subtexts of this poetry are deep, even mythic. Then the poet returns to the realm of the everyday:

Recuerda cuando pusiste	Remember when you put
tus manos sobre las mías,	your hands on mine,
y llorando, me dijiste	and crying, you told me
que jamás me olvidarías.	that you'd never forget me.
Y es lo primero que hiciste	And that's the first thing you did
con tus malas compañías.	with your bad company.
Cecilia, lindo amorcito.	Cecilia, beautiful little love.

If Cecilia is a real woman, she is a tease and a flirt. If she is an allegorical woman and Christian muse, like Jesus himself, she doesn't mind associating with "bad company" and tries to inspire even bad poets. The genius beauty of the poetry of the mariachi lies precisely in its playful ambivalence, its flirtation with the divine and with the human.

Dawn breaks over and illuminates the rosy cantera stone masonry of the plaza, the traditional *glorieta* or bandstand, the gaping maw of the new Eastside Gold Line Metro station and the graceful stage that shares a common wall with it. Many tons of this volcanic *cantera* stone were imported from Jalisco, the Mexican heartland of mariachi, as well as fancy wrought-iron benches, each with the name of a Jalisco town. Quarry cantera stone symbolizes permanence, beauty, and influence. Baroque churches are made of it. Black *tezontle* quarry cantera

stone was the facing for Aztec pyramids and was used in the facades of federal buildings to symbolize centralist power all around Mexico during the endless presidency of Porfirio Díaz. Here in Los Angeles, the layer of beautiful cantera in the plaza symbolizes the very foundations of the mariachi traditions. It acknowledges this plaza as part of a network of plazas and cultural spaces in which the tradition evolved and was negotiated by its artists and its public.

Preeminent in the list of mariachi spaces is, of course, Plaza Garibaldi in Mexico City and the cantinas that surround it, like the famous Cantina Tenampa. In the mariachi heartland—or "Jalmich," as Ochoa Serrano affectionately calls it—Jalisco and Michoacán, the most famous mariachi plazas are in the capitals and environs. Guadalajara, the "Perla de Jalisco" and center of *tapatío* (Jaliscan) culture, boasts not only the plaza of San Juan de Dios market, but also the Parián market of nearby Tlaquepaque, and all the way down to the shores of Lake Chapala and the old freshwater port of Ocotlán, where mariachi tourism exploded after World War II. In Morelia the Plaza Carrillo was where mariachis used to congregate, but many have migrated to the plaza of the old San Agustín convent. These are all centers where the intangible heritage of mariachi culture converges, and so their importance is not in their stones and mortar, but in the space that they lend where the culture is nourished and thrives. It can be argued that every town in Mexico has such spaces, since mariachi flourishes in the entire nation, and most correspond with that most central of spaces, the plaza.

Mariachi Plaza de Los Ángeles is in no way peripheral to this network, but is rather an epicenter of its own. What has happened in Boyle Heights and East L.A. changed and expanded mariachi traditions to include new meanings for both Mexicos, the republic south of the border and the millions of Mexicans who live north of it. If mariachi in Mexico is the symbol of national pride, in the United States it is a symbol of international pride and the assertion of transnational identity and the human rights on which it is based. Recently,

Santo Toribio Romo /
Saint Toribio Romo

new spiritual traditions have emerged around transnationalism as
well. A newly minted Mexican saint, Santo Toribio Romo, has
emerged since his 2000 canonization to champion human rights and
protect immigrants. From the highlands of Jalisco, he was martyred
in the Cristiada, the religious wars of the 1920s. He receives petitions
and prayers from growing numbers of devotees for safe border cross-
ings and to reunite separated families. Shiny button-style reliquaries
of his youthful face have begun to appear among the silver buttons
of the mariachis.

Aquí en este lado, here on this side of the border, migrants' rights,
women's rights, and the goals of the Chicano movement have all been
articulated through the art of the mariachi. The extraordinary trum-
peter and ethnomusicologist Daniel "El Camarón" Sheehy asserts that
mariachi in a U.S. context has been "an agent for social change.[5] His
phonographic chronicle (with Smithsonian Folkways Records) of the
career of Natividad "Nati" Cano and his group Los Camperos, the
"Country People," of Los Angeles, documents the elevation and dig-
nification of the mariachi ensemble and profession. Before, a star-
driven system prevailed that privileged singers and eclipsed the artistry
of the musicians, relegating them to the role of secondhand extras.
New spaces to cultivate musical excellence have been opened up for all.

On the western end of the plaza, one of those spaces is occupied
by the bronze statue of Lucha Reyes in her iconic, sequined "*china
poblana*" dress.[6] She stands in a defiant pose, shoulders back, and sing-
ing to the wind. She was the first female singer to challenge the male-
dominated world of the mariachis, and her career broke the gender
barrier when she lived and performed in Los Angeles between 1920 and
1924. Her rousing performance of "Jalisco, no te rajes," that is, "Jalisco,
never give up," helped convert this regional song into an anthem, and
her endearing movie-based persona of *La borrachita*, the extroverted
"little drunk," was too close to her tragic personal life for comfort. She
opened the door for other famous divas like Lola Beltrán, Amalia
Mendoza, and Ana Gabriel. Her legacy continues with the female

mariachi groups, like the pioneer "Reyna de Los Ángeles," which was followed by many others.

Although the plazas still retain their central location, in the United States another important space has opened for the enactment of mariachi traditions—the mariachi festival, with concerts, dances, workshops, lectures, and master classes, beginning with the first San Antonio International Mariachi Conference in Texas in 1979. The Tucson International Mariachi Festival blossomed in 1983, followed by Fresno's ¡Viva el Mariachi! Festival and many others, large and small, every year since in San José, Los Ángeles, Albuquerque, Las Cruces, El Paso, and beyond. The explosion of mariachi culture in the United States has gone hand in hand with the national movement of high school mariachis in all the centers of Mexican American population.

Finally in 1994, the phenomenon that serves more than one hundred thousand participants in the United States went full circle back to the homeland with the first formal festival symposium held in Mexico, the Primer Encuentro Internacional del Mariachi en Guadalajara. Certain musicologists have made the critique that some standardization of the central mariachi repertoire has occurred and that there is less diversity in musical styles and instrumentation. Others have countered that this mass phenomenon has set the stage for a broad-based and unprecedented interest in the tradition, its history, and its roots in the regional musics of western Mexico.

The association of groups in L.A.'s Mariachi Plaza rides high on this tide of music and cultivates its own cycle of street-based festivities, like the fiesta of Santa Cecilia, as well as thematic festivals that explore

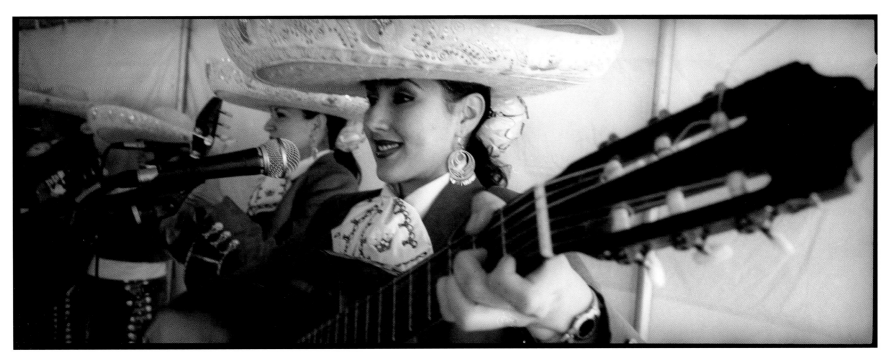

Mujeres y guitarras / Women and Guitars

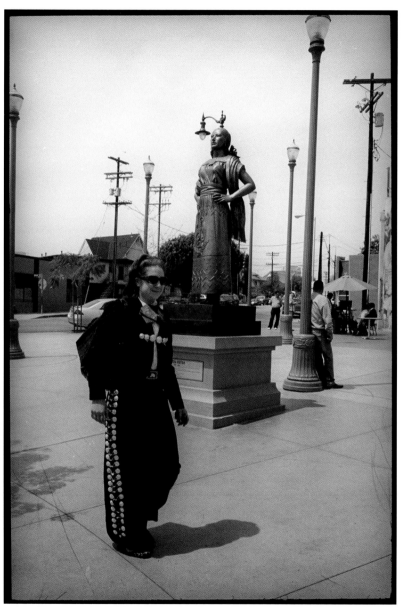

Lucha Reyes y sus hijas / Lucha Reyes and Her Daughters

special aspects of mariachi culture. One featured the new women's ensembles that have emerged across the Southwest. In 2007 the theme was the celebration of the *arpa*, the great harp, which because of its size had been replaced in many ensembles by the guitarrón, an instrument that easily lends itself to ambulatory applications. On a daily basis, most mariachis based on the plaza work for hire *al talón*, literally "by their heels," to go off to private gatherings or other locations. Relatively few groups get to work *de planta*, at a set location like Nati Cano's famous restaurant inn, La Fonda de los Camperos. The 2007 festival renewed the pact with the harp with a public oath: "We will not forget you." Never before had the City of the Angels seen so many harps congregating and blending together, the Jalisco-style harp, and the *arpa grande* from Michoacán. This largest of Mexican harps requires two musicians to play—one plucks and strums the strings, and the other kneels and drums out the rhythms on the sound box.

Despite the shifting and proliferation of spaces where mariachi culture is enacted and negotiated, the plaza abides even as it changes. Mariachi Plaza de Los Ángeles began as a business center for Boyle Heights in the 1880's, with the gradual suburbanization of the land of the López family across the river from the original pueblo of Los Ángeles. As Catherine López Kurland has told us, generations later, one of the daughters, Sacramenta, married a forty-niner from the region near Trieste that belonged to Catholic Austria (also known as Dalmatia, and later, Croatia), who settled down after the Gold Rush, anglicized his name, and built the Cummings Block and the Cummings Hotel. Almost overnight the hotel became the social and cultural center of the area. Then all was lost in the financial crash of 1893. A few years later refugees from the revolution south of the border further Mexicanized a city with deep Mexican roots. Across a new border, what was once the movement of people to follow crops, industry, and jobs is now called immigration. Las Hermanas Padilla, a popular sister duet in 1920s Los Angeles, captured the spirit of the times in their song "Los que vuelven," or "Those Who Return":

Yo ya me cansé, mi mama,	I am so tired, my mama,
de vivir tan desdichado,	of living so wretchedly,
por qué no vendemos todo	why don't we sell everything
para irnos al otro lado.	to go to the other side.[7]

The lyric is, of course, ambiguous, since either side could be the desired destination. After the revolution, when mariachis emerged as a national icon, their music carried the same symbolism to the north. Musicians started appearing on the Boyle Heights plaza. The music, as well as the people, survived the xenophobic mass deportations of 1930–1931 and then returned in force to serve the North American Union and their "*tío*," Uncle Samuel, in fields and factories in World War II. Longtime resident Lucy Delgado recalls seeing mariachis gather on the plaza when she was a small girl walking to school in the 1930s. As industrial development began to pass Boyle Heights by, the residential community became home successively to Jewish families from Eastern Europe, Japanese, and Mexicans. These groups were excluded from other neighborhoods by restrictive covenants until the Supreme Court struck them down in 1948. By the 1950s, second- and third-generation Mexican American families began emerging in greater Los Angeles, and the demand for mariachi music grew as a source of cultural pride and identification. The nickname of the Boyle Hotel was now beginning to be "Mariachi Hotel," and it welcomed musicians and singers, especially in the springtime wedding season. Its Victorian flourishes, fancy brickwork, and Queen Anne cupola lent a sense of prestige and dignity. A cultural economy began to emerge with the plaza as its center, now called Mariachi Plaza.

My guide to the plaza is Roberto Mendoza, who directs his own mariachi. When we met at the mañanitas, he was in sweat clothes displaying the same information that was on his business card: "Mariachi Los Rancheros—A sus órdenes para cualquier evento social" (at your service for any social event), plus a blue silhouette mariachi logo with his slogan on the rim of his hat: "La música más bonita del mundo," the

most beautiful music in the world. Later at the procession and mass, with his violin, he was resplendent in his white suit with red tie, embroidered belt, and gold buttons. Don Roberto's personal story of persistence and triumph, of "*amor al arte*," the love of his art, is intertwined with the history of Mariachi Plaza, the address, and the 90033 zip code that appears on his card. He came to Los Angeles as a young man over thirty-five years ago with his music and the desire to perform it. Even before he got his immigration papers four years ago, he managed to return most years to Sahuayo, his hometown in Michoacán for fiestas—a pilgrimage of thanksgiving. The patron saint of Sahuayo is Santa Cecilia herself. He says proudly that he never spends more than two weeks in Mexico since his home is Los Angeles and its overflowing *fuente de trabajo*, fountain of work. Don Roberto's musical talent supports family on both sides of the border. His first five years in the late 1970s, he lived in Mariachi Hotel, later moving to the surrounding neighborhood. The early years were rough, because of constant pressure from "La Migra," or immigration police. He traveled straight between gigs and the hotel to avoid appearing unnecessarily in public. Later times were more relaxed with the amnesty of the 1980s. He is proud that the plaza and hotel are being renovated and the atmosphere preserved. He is proud of his profession and in love with his music:

> Y queremos que más y más gente venga a presenciar y vea lo
> que los mariachis hacen por el pueblo. Por amor al arte.
> (We want for more and more people to come and witness and
> see what the mariachis do for the people. For the love of art.)

Don Roberto's story parallels the lives of hundreds of mariachis in Los Angeles. Some are dual citizens, some legal residents, some are Mexican American, and some have come *por cerro*, "through the hills" of the Tijuana border as he once did.

At Mariachi Plaza, music for hire became a full service economy, with specialized tailor shops, printing shops for flyers and business

cards, music schools, Mexican restaurants, grocery stores, and, of course, housing. Even a deeply stylized tradition has to evolve to survive. Freelance musicians carry different colors of mix-and-match ties, depending on how large a group a patron can afford. As more permanent groups coalesce, different colors of mariachi costumes are now sewn to add reds, browns, even white to a palette previously dominated by somber black. Now every musician carries a cell phone so no opportunity for a gig will be missed. Performances are captured on these phones and miniature video cameras to share on YouTube, where new groups also make their debut.

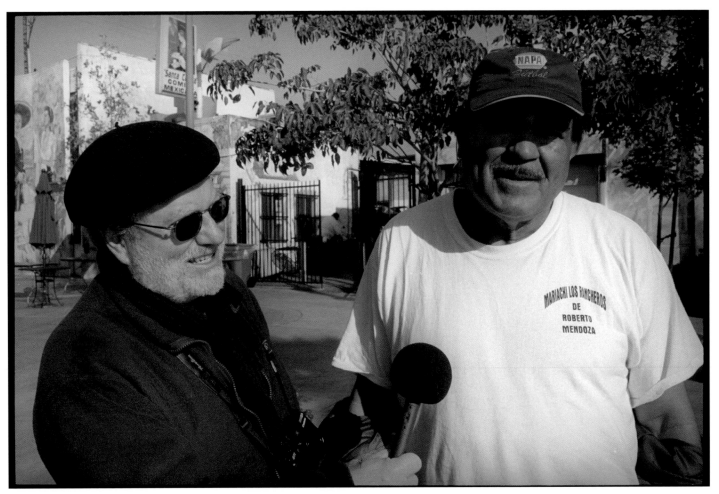

Don Roberto y su amigo / Don Roberto and His Friend

But no virtual space can replace the plaza. Just as in Plaza Garibaldi in Mexico City, dozens of mariachis congregate at Mariachi Plaza every day, around the clock on weekends, to wait for patrons to hire them to perform in all kinds of family and community gatherings. Some enthusiastic patrons come to sing along right there and pay by the song. Secular occasions that require mariachis include simple birthday parties, midnight serenades for a lover, elaborate receptions for quinceañeras where fifteen-year-old girls emerge as women, dances, betrothals, and graduations. More religious occasions include weddings, baptisms, confirmations, and funerals. Radiating from its

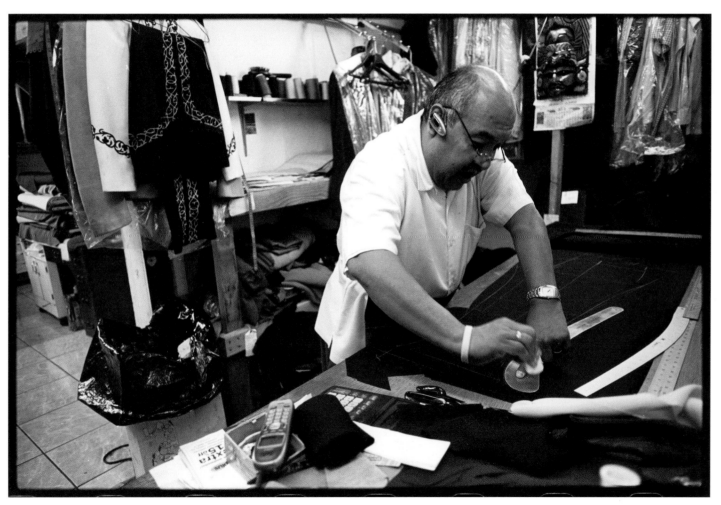

Todo a la medida / Everything Cut to Order

Fiesta Anual de Santa Cecilia

A todos se les hace la cordial invitación para festejar a la Patrona de los Músicos

martes 23 de noviembre del 2010

Se les pide su asistencia para honrarla con las mañanitas en el lugar de siempre, iniciando a las 5:00 a.m. Luego continuaremos con la peregrinación a las 10:00 a.m. más tarde se oficiará la Solemne Misa a las 11:00 a.m.

Al termino de la misa, proseguirá el festejo con los Mariachis que participarán de 1:00PM a las 10:00PM.

Pedro Torres con Mariachi Juvenil Camino Real Mariachi Sol De Mexico Mariachi Los Toros Trío Los Muñecos Mariachi Juarense de Andres Niri

El Mariachi Los Rancheros de Mario Hernandez Grupo Lucero Del Norte Los Cuates de Jalisco Mariachi Internacional de Mexico Banda Sinaloese Nueva Generacion

También! Mariachi Santa Cecilia, Banda Sinaloense Rio Grande, Grupo Los Alegres de Paramount

Estamos Localizados en Mariachi Plaza
En la esquina de las Calles 1ra y Boyle

Para más Información Llame a
Leno Caro a (323) 574-6731 o Artuo Ramirez (323) 309-4818

Santa Cecilia Fiesta poster

"Jalmich" homeland in all directions, mariachi music has become a component of Mexican folk ritual. Just as no saint's day or birthday is complete without "Las mañanitas," no funeral is finished without "Las golondrinas," a swallow song about eternal return and the journey of the soul. Triumphs of all varieties receive their musical laurels in the form of a Diana, a lively flourish that precedes and follows applause and cheers and sounds like the music of the French cancan.

Popularized by the singing charro movie stars of 1930s, 1940s, and 1950s classic cinema, the *canción ranchera*, Mexican country song movement, bloomed to the accompaniment of mariachis. Handsome singers like Pedro Infante, Javier Solís, and Vicente Fernández could be seen as well as heard. Less photogenic greats like José Alfredo Jiménez claim their fame through the florid metaphors of their poetry and the Dionysian passion of their performances. Mariachi embraced these popular developments as it had the musical fads of the nineteenth century. But it draws its impressive staying power and perennial appeal from deep roots in the traditional *son*. Each region boasts its own varieties where *sones* are also known as *gustos, malagueñas, peteneras, huapangos*, and the *chilenas*, which were based on the *cuecas*, the syncopated dance tunes that Chilean sailors and miners brought north along the Pacific coast. The sweet jarabe dances of the mariachis are based on fragments of *sones*, which change tempos as the dancers follow. The appetite and necessity of political satire is satiated with the *valona*, always sung with the same melody in *décima*, ten-line stanzas, with alternating *recitative*, recited verses, laced with erotic double entendres. Most valonas are unsuitable in polite company; they target politics, religion, and any other painful topic that laughter can help massage.

The sacred repertory of the mariachi is based on the more subdued *minuetes*, more in keeping with a reverent setting. Also, several variants of a Mariachi mass are as widespread as they are popular. On the day we were there, a moving and colorful Misa Mariachi, in honor of the mariachis and their patron saint, was held on Mariachi Plaza. After the morning mañanitas, over a dozen groups appeared with hundreds of

musicians dressed in their finest costumes. The roster of names and pictures on the fiesta program cover a broad musical geography, from central Mexico to Alta California. A range of ages and degrees of celebrity are well represented, as are ensemble sizes. Where available, the number of participants from each group is listed in parentheses:

Pedro Torres con Mariachi Juvenil Camino Real (11)
José Hernández con Mariachi Sol de México (13)
Mariachi Los Toros (10)
Trío Los Muñecos (3)
Mariachi Juarense de Andrés Neri (7)
Mariachi Los Rancheros de Mario Hernández (9)
Grupo Lucero del Norte (4)

Los Cuates de Jalisco (2)
Mariachi Internacional de México (10)
Banda Sinaloense Nueva Generación (20)
Mariachi Santa Cecilia
Banda Sinaloense Río Grande
Grupo los Alegres de Paramount

Players, singers, and their families left in procession to walk a circular route through the surrounding neighborhoods as pilgrims, returning eventually to the plaza. In the lead, women in colorful shawls carried Santa Cecilia. The musicians fell into instrumental groupings, with dozens of trumpets followed by contingents of guitars, and a sweet army of violins, playing together to project their sound.

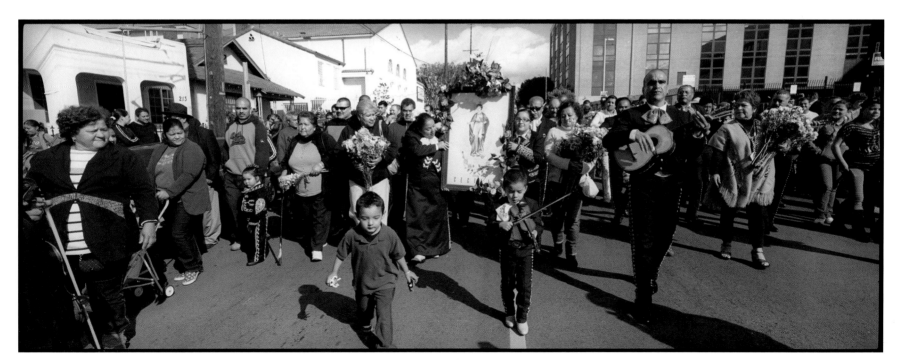

La música nos une / Music Unites Us

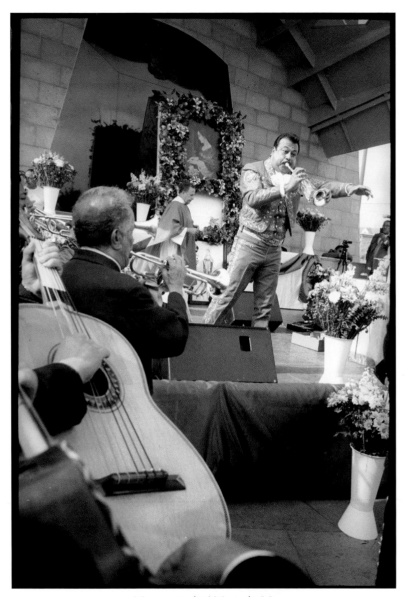

Misa mariachi / Mariachi Mass

The guitarrones were scattered around the group because they marked bass time for the shuffling feet. The only absent instrument was the arpa, since it is not very portable. The entire group filled a city block at a time, yet managed to play the same songs, in time and together as one. No tourists were in sight. In this pilgrimage, the mariachis play for themselves and for Santa Cecilia. All the other days of the year they perform for others.

The priest was not a mariachi, but he sang with them and praised their music to the heavens. His prayer is their prayer for dignity and survival: "Dios, dame un trabajo digno y bien remunerado," directly asking God to give him work with dignity and good rewards. Santo Toribio Romo also hears these prayers. In the homily the priest invoked not only the beautiful virgin Cecilia, but also the beautiful Virgin of Tepeyac, la Guadalupana, present also in Los Angeles, California, and the United States:

> que viene a este país a cuidarnos, a bendecirnos, a ayudarnos a los que no tenemos papeles. Entreguémonos a la Virgen . . . vamos todos peregrinando, tocando nuestros instrumentos, mostrando nuestra cultura, mostrando que somos mexicanos. (who comes to this country to bless us, to help those of us who are without papers. Let us deliver ourselves to the Virgin . . . let us go in pilgrimage, playing our instruments, showing our culture, showing that we are Mexicans.)

Mariachi lyrics often invoke the metaphor of pilgrimage and the swallow, its diminutive totem bird, to sanctify with purpose and love the comings and goings of people across great distances and borders.

In the 1930s, Casa La Golondrina on Olvera Street was one of many popular Mexican restaurants in Los Angeles that offered regional delicacies, culinary and musical, to remind patrons of Mexico. In the Library of the University of California, Los Angeles, Álvaro Ochoa Serrano found illustrated newspaper ads complete with menus

that also mentioned which mariachis were playing.[8] Even their lyrics ended up in print. Early recordings of entire performances are preserved in the Arhoolie Foundation's Strachwitz Frontera Collection of Mexican and Mexican American Recordings. This verse sung by Mariachi Coculense el Costeño demonstrates the emergence of a regional consciousness complicated by immigration and laced with nostalgia:

A Los Ángeles llegó	To Los Angeles arrived
el mariache tapatío;	the mariachi from Jalisco
y con él recuerdo yo;	and with him I remember
de un amor que fue muy mío.	a love that really belonged to me.

"Tapatío" is the nickname of anyone or anything from Jalisco. Other memories are more somber. Separation from family and loved ones also causes pain. Here a ghostly shadow arrives and causes a man to shudder:

Él me dijo muchas veces	He told me many times
¿por qué tiemblas, tienes frío?	why do you tremble, are you cold?
Será que llegó la sombra	It's just that the shadow arrived
de tu padre y de tu tío.	of your father and uncle.

In the following recited verse the mariachi speaks in first person as he looks south and sings to his native land:

Desde la Alta California	From Alta California
le canto a la tierra mía	I sing to my own land
porque dentro 'el pecho llevo	because in my heart I carry
el amor de una tapatía.	the love of a woman from Jalisco.

Again, the plaza and L.A. itself were and are epicenters of mariachi culture. By the 1940s all the most iconic mariachis of Mexico, like Mariachi Vargas de Tecalitlán, had toured Los Angeles, and a procession of other key groups like Los Reyes de Chapala followed. They performed in the finest venues of Southern California. Did they ever visit Mariachi Plaza or stay at the Mariachi Hotel? This is the poetry of Mariachi Plaza.

In truest form, mariachi lyrics play freely with ambivalence and ambiguity in the form of humor. Here a singer pokes fun at the challenges and foibles of transnational love. This verse represents a lover's quarrel with international complications. She threatens to leave for Mexico, and he is crying because she won't leave soon enough.

Ay, que me voy, que me voy,	Ay, I'm going to leave, I'm going,
para México lucido.	for resplendent Mexico.
No lloro porque te vas, negrita,	I don't cry because you're leaving, honey,
sino porque no te has ido.	but because you haven't left yet.

The term of endearment, "negrita," lends a special insight into the mestizo culture of the mariachi and Mexico itself. In English translation, the term is erroneously racialized and stigmatized because of its apparent reference to a woman or girl with African features. Negro or black was a caste term in colonial Mexico or New Spain, but the process of cultural and racial hybridity progressed with such speed that mixed castes were soon almost impossible to classify. With independence from Spain, the caste system and its codification of inequity were immediately eliminated. Negro/a and the diminutive negrito/a survive as a relic of cross-caste desire and intercultural and interracial love. Although "dark one" lends a shade to the meaning, the more appropriate translation would be: honey, sugar, sweetie, darling, or sweetheart, depending on the rhyme scheme of the lyric!

It is no accident that the most instantly recognizable mariachi *son* of all would be "Son de la Negra"—the traditional opening song of a set of mariachi music. As we complete a circle of reflection on mariachi culture, we listen to this beginning with new appreciation. The anecdotes of music history tell of Fidencio Lomelí Gutiérrez, from Tepic, Nayarit, the city on the route from the Pacific to the highlands of Jalisco. His youthful obsession and unrequited love for his fifteen-year-old "negrita" was as ordinary as it was legendary. A vendor, cigar maker, and seamstress, Albina Luna Pérez was as beautiful as she was headstrong. As in a multitude of love songs, the amorous dilemma revolves around the words "sí," "no," and "cuándo," the desperate question "when?" Fidencio's mariachi brother Alberto set the poem as a song in 1926. What transformed it from regional song into national anthem was a chance meeting with Silvestre Vargas of the iconic Mariachi Vargas de Tecalitlán. He arranged "La Negra" into the compelling musical conversation between violins and trumpets that we know and love today. Trumpets had recently been added to the mariachi ensemble to brighten and project the melodies, but also to carry better over the radio waves. The radio carried the greatest mariachi hit of them all on the winds to the four directions.

The poem itself plays with the pain and ecstasy of love, the promise of fulfillment and the reality of frustration. The fleeting and flirting metaphor of La Negra's eyes and flying paper suggests a context of festival celebration, with streets strung with colorful cut-out *papel picado* and strewn with confetti.

Negrita de mis pesares,	Sweetheart of my grief,
ojos de papel volando.	eyes like confetti flying.
Negrita de mis pesares,	Darling of my sorrow,
ojos de papel volando.	eyes like paper soaring.

This simple poem captures the mischievous, ambivalent spirit that motivates mariachi music and culture. Like the doves of the four directions, it has flown from the country to the cities of greater Mexico and the world, providing nostalgia and consolation, even across borders. Like La Negra, it has promised everything to everyone:

A todos diles que sí,	Tell everyone yes,
pero no les digas cuándo.	but don't tell them when.
Así me dijiste a mí,	Like you said to me,
por eso vivo penando.	that's why I live in suffering.

Mariachi dresses the peasant musician in the costume of wealth and authority. It exults in masculine energy that women also have appropriated. It brings respect and a good living to the humble souls foolish enough to dedicate their lives to art. The mariachi struts and swoons, moans and hollers. Its poetry is simultaneously commonplace and sublime. Mariachi violins, guitars, trumpets, and harps alternate seamlessly between the profane and the sacred. Its ultimately chaste poems of love promise fulfillment, not consummation. The central predicament is absence and alienation. When will La Negra return to me?

¿Cuándo regresa mi negra?	When will my sweetie return?
Que la quiero ver aquí,	For I want to see her here,
con su rebozo de seda	with her silk shawl
que le traje de Tepic.	that I brought her from Tepic.

I have dressed her in the finest Chinese silk from the galleons of Manila, but she is still nowhere to be seen. How will I end my suffering? The pain of love is sweet, and frustrated desire makes it sweeter. There is hope as long as there is music, as long as the muse is served. The beauty of Santa Cecilia, the mariachi muse, is as real as desire and hope and the music that puts the wings of angels on it.

All is musically resolved at the end of every song in the signature mariachi cadence and flourish. However painful the love, however long the pilgrimage, however great the sacrifice, we are assured of

return and resolution. If the tonic begins and ends the journey of the scale, the return to the tonic is the return home. The subdominant to tonic ending is the reassurance and the hope: "tan-TAN."[9]

On the plaza, as I stood in line after mass for the delicious *caldo de mariscos*, the seafood stew that was offered to all, I heard a familiar joke. Roberto Mendoza repeated to me the most famous mariachi story of all, set in every conceivable context, wherever the music and culture are celebrated. It sums up life, ambition, desire, love, and death, mariachi style.

Este era un mariachi trabajando al talón aquí en Mariachi Plaza. Había esperado una chamba todita la tarde cuando entró al hotel un rato. Entonces pasa un señor que quería llevarse a cinco para una tocada. Sale a andar la camioneta y viene corriendo el mariachi. Cuando cruza la calle sin mirar, ¡zas!, lo atropella un carro. Para la camioneta con sus amigos y salen. Ven que está ya agonizando, pero les señala que le acerquen, quizás para decirles sus últimas palabras. Se arriman los amigos. Levanta la cabeza, los mira y les dice: tan-TAN.

(There was this mariachi freelancing here on Mariachi Plaza. He had waited for a gig all afternoon when he went into the hotel for a minute. Then this guy comes by who needed to hire five musicians for a performance. The van leaves and the mariachi comes running. When he crosses the street without looking, *zas!*, a car runs him over. The van with his friends stops and they get out. They see that he is dying, but he signals them to come over, maybe to tell them his last words. His friends go over. He lifts up his head, looks at them and says: tan-TAN).

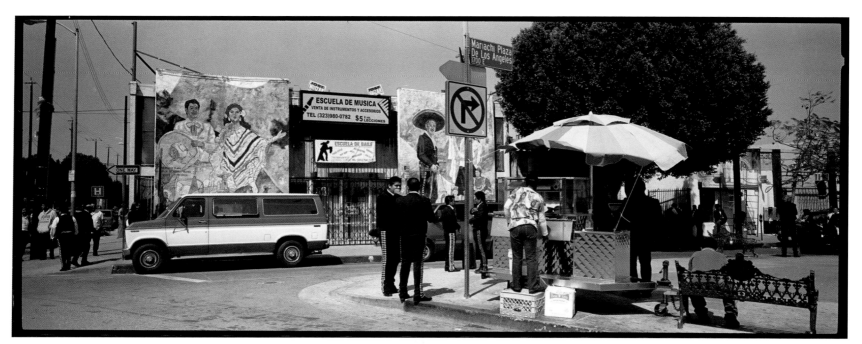

Por aquí hay de todo / You Can Get It All Here

La música en todas las casas / Music in Every House

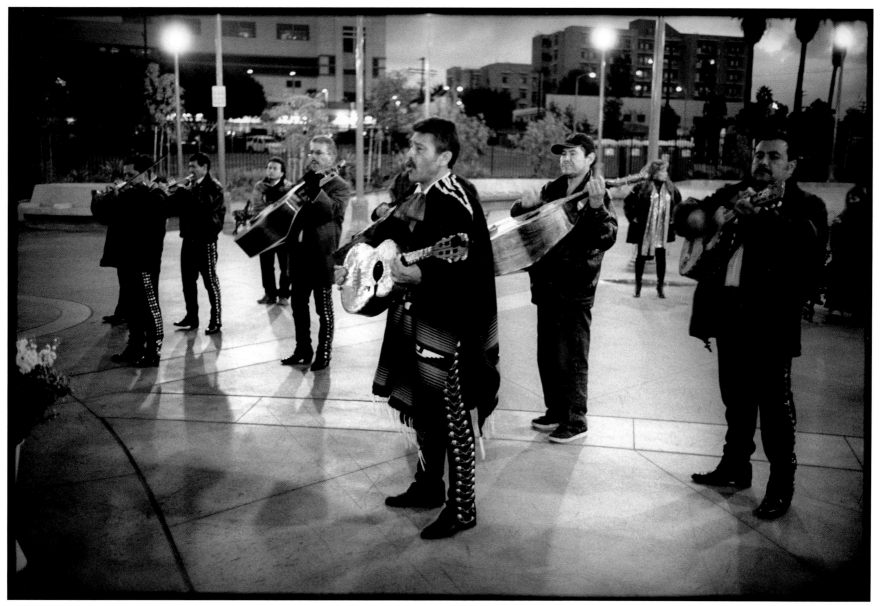

Rayando el sol / First Rays of the Sun

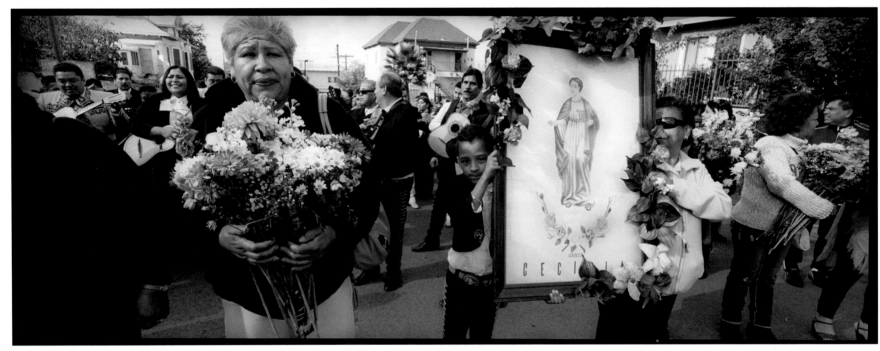

Flores para la Virgen Cecilia / Flowers for the Virgin Cecilia

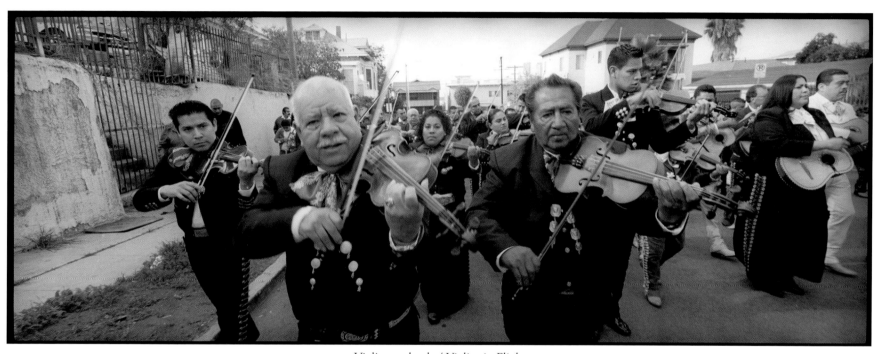

Violines volando / Violins in Flight

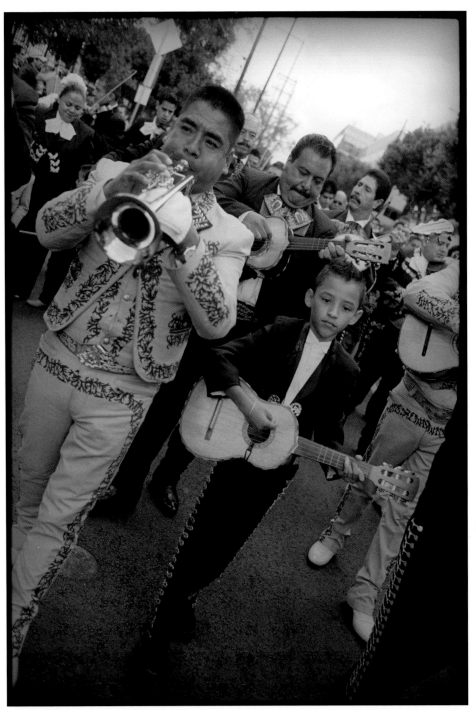

Futuros mariacheros / Mariachi Futures

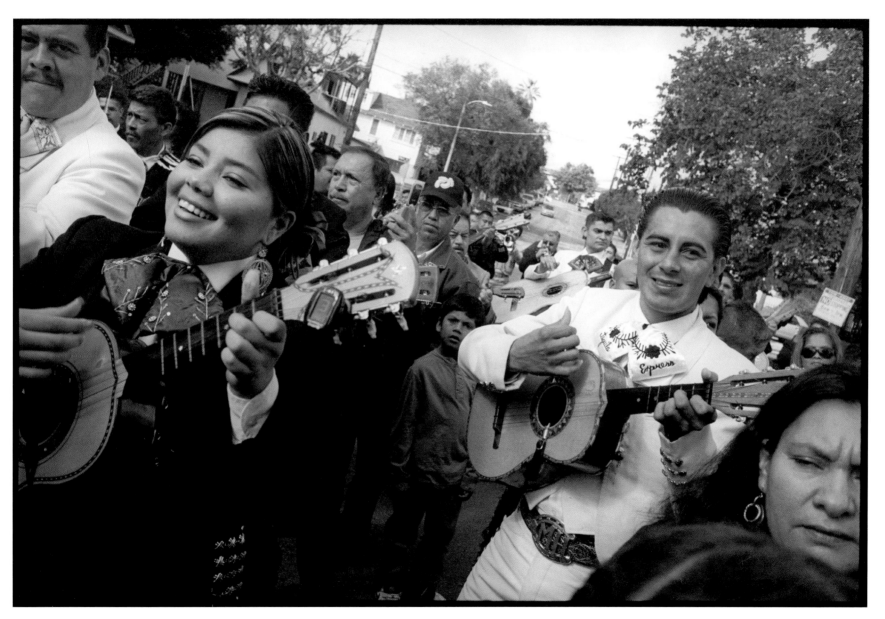

Sonrisas cantando / Singing Smiles

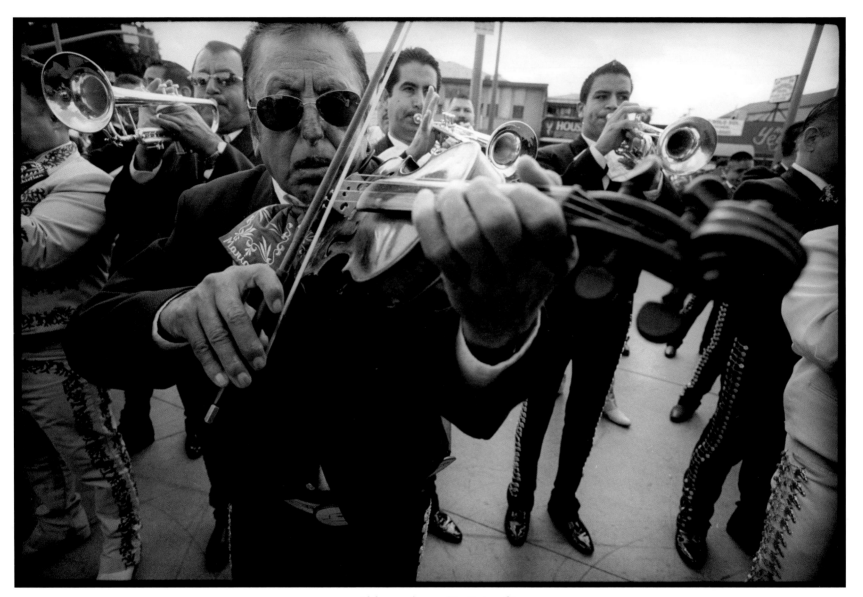

Alabanza al amor / In Praise of Love

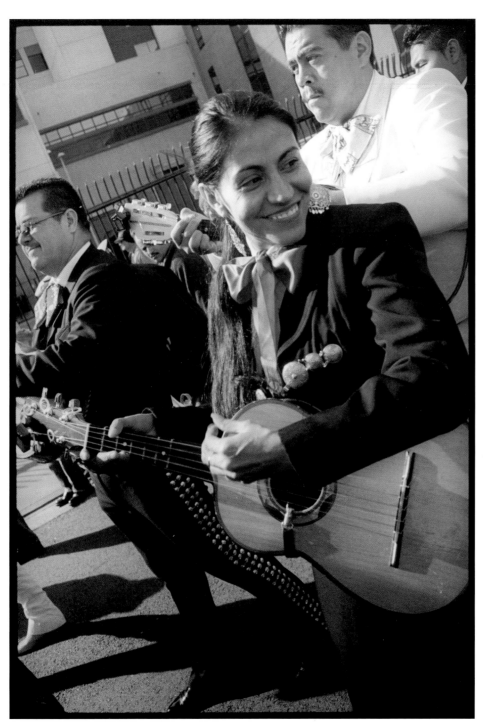

Vihuela angelical / Angelic Vihuela

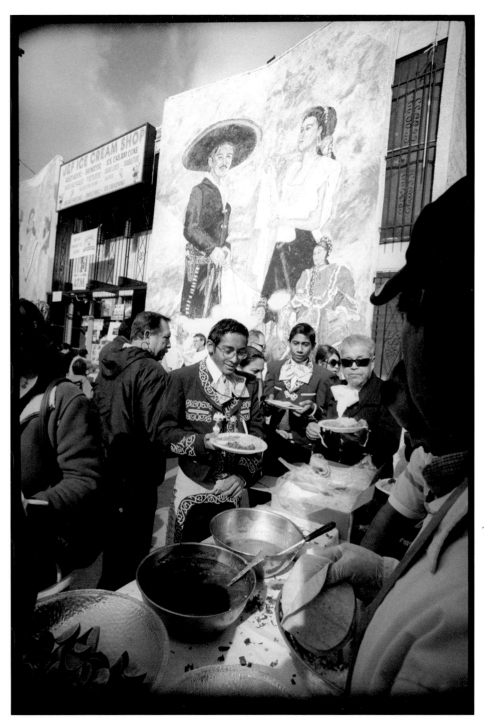

Tortillas para todos / Tortillas for Everyone

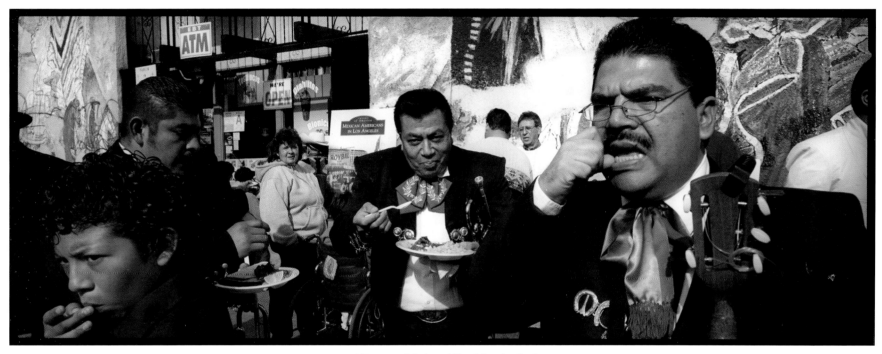

Alimento del alma / Food for the Soul

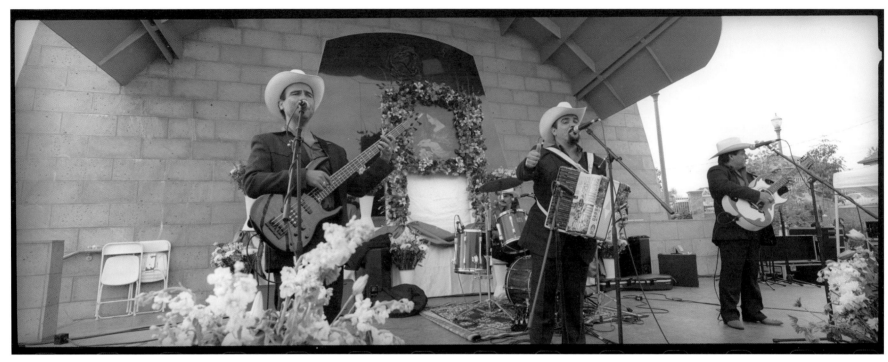

Conjunto del norte / Northern Style Group

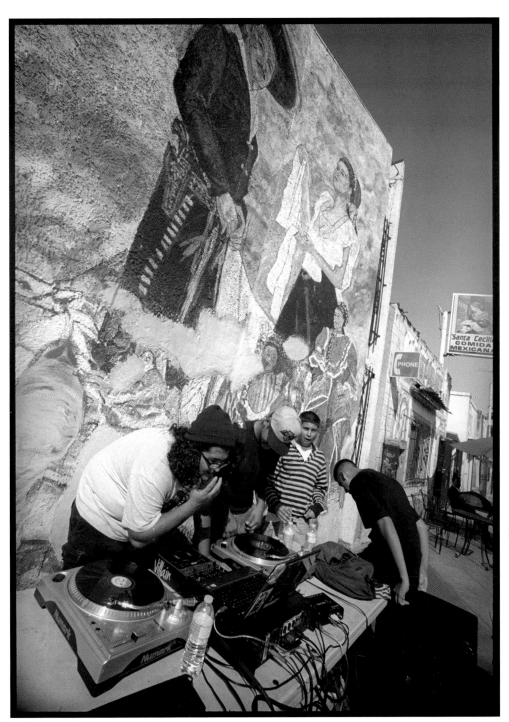

Hijastros / Stepchildren

Mariachi Hip Hop / Mariachi Hip Hop

Boogie en la plaza / Boogie on the Plaza

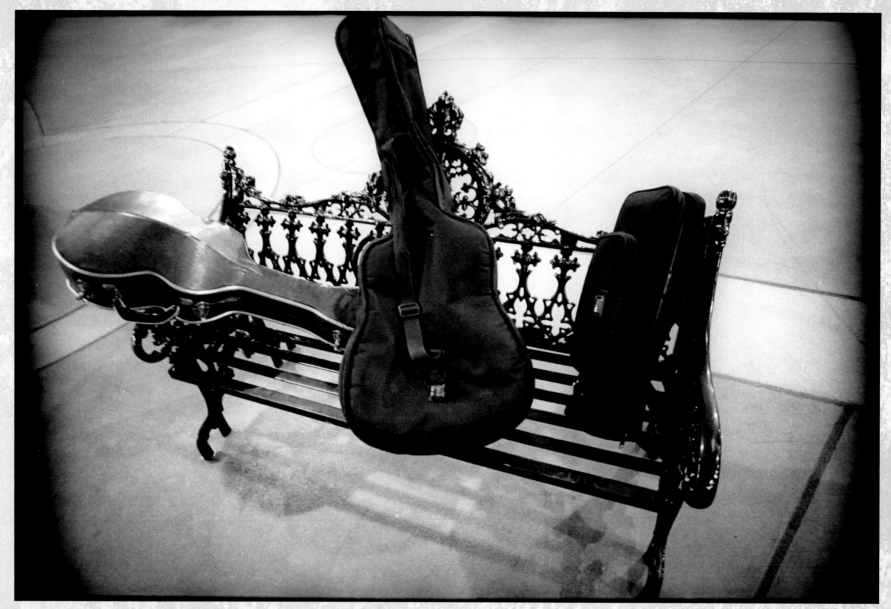

Banco de Jalisco / Bench from Jalisco

Acknowledgments

We are deeply indebted to the mariachis of Boyle Heights. These professional musicians are the inspiration for this book. Their music reaches out to each one of us, bringing us together to listen, and to admire and respect the vibrant cultural tradition that they continue to celebrate even across borders.

We are fortunate that W. Clark Whitehorn, editor in chief, University of New Mexico Press, believed in this project from the moment Miguel presented it to him. We appreciate the assistance of everyone at University of New Mexico Press and, in particular, the production expertise of Felicia Cedillos, the design vision of Catherine Leonardo, and the masterful copyediting of Rosemary Carstens.

From Catherine L. Kurland:

This book started out as a handful of photographs to document the old Cummings Hotel before it was torn down. The hotel opened me to so much: to my mother's family history, the mariachis, Boyle Heights, and people who have become an important part of my life. One of the first to grasp the significance of this hotel and place was Miguel Gandert. His immediate understanding gave me the courage to try to save the building. I cannot be sure about what might have happened to it or the mariachis without Miguel's powerful images, but I do know that without them there would be no *Hotel Mariachi*, the book. I will always be grateful to him for making this possible.

When Miguel brought his friend and colleague Enrique Lamadrid on board, our team was complete. Enrique carved time from his teaching schedule at the University of New Mexico to come to Los Angeles for Santa Cecilia Day, bringing with him his recording equipment, an appreciation for the nuances of the Spanish language, and the ability to dig deep into the layers of meaning hidden in the lyrics. With his enthusiasm and focus, Enrique set us on our way to publishing our book and has brought us closer to the mariachis and their music. It has been a privilege and a pleasure to work with him and, through him, his ethnomusicological colleagues Álvaro Ochoa Serrano of the Colegio de Michoacán; Peter J. García of California State University, Northridge; and David F. García, University of Texas, Austin.

We thank Evangeline Ordaz-Molina for weaving the threads of this book together from her perfect vantage point. As a founding director of the East LA Community Corporation (ELACC), and as someone who grew up in the neighborhood, she knows the back story. As much as anyone, Evangeline understands the value of the history of place and has been unwavering in her support. Evangeline and ELACC President María Cabildo courageously purchased the Boyle Hotel because of its value to the community. Their efforts to restore the dignity of the Cummings Block and preserve the core role of the mariachis inside and outside its doors are a gift to all of us. Over the past five years one of the highlights for me has been the pleasure of working with the gracious staff at ELACC, who have made me feel like family. In addition to María and Evangeline, I want to express my special appreciation to Isela Gracián, Janet Favela, and Marisa Quintanar.

The first person I met in Boyle Heights was Diana Ybarra, founding director of the Boyle Heights Historical Society. I am thankful to her for her work on the Los Angeles Historic-Cultural Monument nomination, for her concern for Boyle Heights history, and for encouraging me to share my family's stories. Thanks as well to the enthusiastic encouragement of other friends and colleagues rooted in East L.A., notably poet and investigative journalist Víctor Manuel Valle who teaches at California Polytechnic State University, San Luis Obispo.

Preventing the old brick Cummings Block from disappearing was the first order of business. The Historic Preservation and Regionalism program at the University of New Mexico has had a defining influence on my life and on this project. This is a stellar program because of the quality of the teaching and, most of all, because of the director, Chris Wilson. He started out as a mentor and became a dear friend and has always been someone I could count on to be there for me. Chris's belief in the worth of the Cummings Block was pivotal. Another New Mexican, former professor and friend Michael Romero Taylor, encouraged me and lent his support by introducing me to preservationists in California who supported the historic nomination: Jay Platt, Anthony Veerkamp, Ken Bernstein, Edgar García, Anthea Hartig, Denise Alexander, Donna Graves, and Mike Buhler. Geraldine Forbes Isais helped me recognize the importance of this old building to people outside of Boyle Heights.

Retired L.A. City Archivist Hynda Rudd led me to the mother lode of archival material in the Los Angeles City Archives. This is a well-hidden treasure chest where I spent many days poring through boxes of papers unearthed by Mike Holland and Jay Jones. Curators, archivists, and librarians throughout the region graciously assisted me with my research. It was a privilege and a pleasure to work at the Huntington Library. I appreciate the expertise and courtesy of this august institution's curators and Readers' Services' staff: Bill Frank, Alan Jutzi, Christopher Adde, Juan Gómez, Kadin Henningsen, Jaeda Snow, and Catherine Wehrey. Others in Los Angeles who graciously shared their archives and their scholarship include Abe Hoffman, Paul Spitzzeri, Glen Creason, Stella Cardoza, Danny Muñoz, and Suzanne Grayson, who played a key role in researching the Cummings and López family history. I am especially indebted to Bill Estrada for generously sharing his deep knowledge of the Hispanic history of our city. His book *The Los Angeles Plaza: Sacred and Contested Space* is must reading for anyone interested in L.A. history.

Searching for historic photographs was daunting and rewarding. Their appearance in this book are thanks to Kathleen Correia at the California State Library; Jenny Watts, Erin Chase, Anita Weaver, and Manuel Flores at the Huntington Library; Dace Taube and Rachelle Balinas Smith at the University of Southern California; and John Cahoon at the Seaver Center for Western History Research for bringing to light long-lost photographs of George and Sacramenta Cummings.

The most precious documents and photographs often come from private collections. It was David Workman who showed me the original deed of sale, from my ancestor to his, for the land that eventually became Boyle Heights—a critical document in this narrative. The other treasure he produced is the professional-quality 1889 photograph of the Cummings Block. I am grateful to Judge Workman for his generosity.

My story, "Pobladores to Mariachis," has evolved over time. I am fortunate to have friends and colleagues who were willing to read my manuscript. For their invaluable encouragement and helpful comments, I am indebted to Jaci Emerson, Ron Samet, Julie Newcomb, and Penelope Bingham. My cousin Carla Rahn Phillips, a historian and my toughest critic, filled in family history and raised important questions; Lori Zabar, former gallery and writing partner, drew my attention to Spanish words and Southwest customs unfamiliar to Easterners and curbed my penchant for exclamation points; Julianne Burton-Carvajal, a California historian, made valuable editorial suggestions; and Virginia Scharff, historian and valued friend, shared keen insights that made a huge difference.

Hannah Shearer, a fine writer, whose friendship began on the first day of third grade, knows what the Cummings Hotel has meant to me. Her clear thinking and infectious laugh have helped me beyond measure throughout this journey.

When my colleagues and I needed a place to stay, my brother, Frank Kurland, did not hesitate to offer us the keys to his beach house. I thank him for his ready hospitality.

Another relative, cousin Bob López, played a crucial role in my odyssey. He had an expansive knowledge of early California genealogy. Until his death at ninety-one, he had a thirst for learning and a twinkle in his eye. Bob opened windows to my ancestry and to a period in Los Angeles history that had been lost to many, including my own family. Getting to know Bob and his beautiful wife, Margaret, was one of the joys of this quest.

I will always be grateful to my sister, Bernay Grayson, for her generous support of this book. Above all, I am gratified to know that she enjoyed and appreciated it.

There is no one to whom I owe a larger debt of gratitude than my husband, John Serkin. From the moment I set eyes on the hotel, he supported me at every turn. I could not have done this without his encouragement, sage advice, humor, and endless patience. A musician himself, John's high regard for the mariachis heightened my own appreciation. If I were to dedicate this book, it would be to my loving husband, John.

Notes

Pobladores to Mariachis

1. *Californios* were Mexicans living in Alta California before 1848 and their descendants.
2. María S. López de Cummings, *Claudio and Anita: A Historical Romance of San Gabriel's Mission Days* (Los Angeles: Rowney Press, 1921), 13.
3. According to family lore, Claudio López studied engineering in Spain and may have returned to California by ship (Carla Rahn Phillips, e-mail message to author, May 31, 2012). From 1806 to 1826, José María de Zalvidea was head priest of La Misión del Santo Príncipe Arcángel San Gabriel de los Temblores (The Mission of the Holy Prince, Archangel Saint Michael of the Earthquakes)—known today as Mission San Gabriel.
4. "Fantasy heritage" is a term coined by Carey McWilliams in the 1940s, referring to a romantic, idyllic interpretation of the history of Spanish California.
5. Cummings, *Claudio and Anita*, vii. John Steven McGroarty (1862–1944) was a journalist, historian, playwright, poet, and advocate for the preservation of California's missions, and is best known for *The Mission Play*, which opened in 1912 in San Gabriel and ran for twenty years.
6. Several months after the founding of Los Angeles, Quintero, age fifty-five, and his family left the pueblo to move to Santa Bárbara, where he practiced his trade as a tailor and helped to found La Misión de San Buenaventura. According to Los Angeles historian William Mason, it is likely that he asked permission to leave in order to be near three daughters who were married to soldiers stationed at the presidio. William M. Mason, *Los Angeles Under The Spanish Flag: Spain's New World*, produced as a complement to *Spanish-Mexican Families of Early California*, vol. 3 (Burbank: Southern California Genealogical Society, 2004), 13–14. http://www.scgsgenealogy.com/storage/Northrup3.pdf.
7. "Diversity Gave Birth to L.A.," *Los Angeles Times*, August 22, 2007, http://articles.latimes.com/2007/aug/22/local/me-founders22. Caste was listed on documents during the Spanish colonial period. The Spanish caste system, which ended with Mexican Independence from Spain in 1821, classified each person by perceived racial characteristics: español—Caucasian; criollo—born in Nueva España of Spanish parents; negro—African Mexican; mulato—español negro; and mestizo—español indio (Indian). A person's caste could change over time: Luis Quintero was listed as negro in the 1781 Los Angeles founding documents and as mulato in the 1790 Santa Bárbara census.
8. Gente de razón was a term used to differentiate Spanish-speaking residents from indigenous people during the colonial period. Non-Indians were classified as gente de razón by the colonists, and California Indians were legally treated as minors. William David Estrada, *The Los Angeles Plaza: Sacred and Contested Space* (Austin: University of Texas Press, 2008), 28.
9. The Mission San Gabriel was founded in 1771.
10. The exact location is not known; in the early 1800s the site was

moved to higher elevations due to flooding. Estrada, *The Los Angeles Plaza*, 30.

11. Ibid., 11. Ibid., 31.

12. Confirmations by Junípero Serra, Mission San Gabriel. Photocopy of a handwritten document courtesy of Robert E. López.

13. For more on the mission's water-powered gristmill, see *Historic American Buildings Survey*, CA-34, El Molino Viejo, Pasadena, California, compiled after 1933, http://lcweb2.10c.gov/pnp/hab-shaer/ca/ca0200/ca0278/data/ca0278data.pdf. "In the year 1826 Los Angeles elected as alcalde one of the outstanding Spanish members of the community, Claudio López, the beloved and almost saintly mayordomo of San Gabriel Mission under Padre Salvedea [sic] and Sánchez, who seems to be one of the few men of the mission period who could handle the Indians without flogging them," J. Gregg Layne, *Annals of Los Angeles From the Arrival of the First White Men to the Civil War, 1769–1861* (San Francisco: California Historical Society, 1935), 16.

14. Cummings, *Claudio and Anita*, 119. Claudio Lopez's adobe was in what is now Arcadia, California, possibly located on the site of the Santa Anita Racetrack. Sacramenta Cummings suggests that the heroine of *Claudio and Anita* was the namesake of Rancho Santa Anita. Wikipedia, Santa Anita Park, http://en.wikipedia.org/wiki/Santa_Anita_Park.

15. Los Angeles City Records, September 30, 1835, recorded on 29 April 1859, Book 4, Page 411, of Deeds, from *Abstract of Title of that Certain Real Property in the City of Los Angeles, County of Los Angeles, State of California, bounded and described as follows: Lands of Sacramenta Lopez de Cummings and George Cummings, her husband, East of the Los Angeles River, 1835–1895*, filed Jan 15th 1895," File "Cummings Tract, 2/1/36–Dec.1894," Box B 2288 "Abel Stearns." Los Angeles City Archives, Edwin C. Piper Technical Center.

16. Layne, *Annals of Los Angeles*, 50–52.

17. Deed, December 30, 1841, Estevan López to Francisco López, from the López and Cummings *Abstract of Title* for 1835–1895. The Treaty of Guadalupe Hidalgo was signed in 1848, ending the Mexican War.

18. Francisca López de Belderraín, "The Awakening of Paredón Blanco Under a California Sun," *Annual Publication of the Historical Society of Southern California* 14, no. 1 (1928): 64–79.

19. Deed, Petra Barrelas [Varelas] and Leandro López to Andrew A. Boyle, dated April 26, 1859, Workman Family archives, private collection; copy in author's collection.

20. Belderraín, "The Awakening of Paredón Blanco," 67–72.

21. Conversation with Robert E. López at his home in Los Angeles, 2011. Brooklyn Avenue is often mistakenly said to have acquired its name in response to the large Jewish population in Boyle Heights in the early twentieth century, but it appears on the 1877 map published as promotional material for the Brooklyn Heights Tract (see fig. 1.5).

22. Layne, *Annals of Los Angeles*, 50–52.

23. Deed, January 30, 1872, Francisco López and Rosario López his wife to Sacramento López de Cummings their daughter, from the López and Cummings *Abstract of Title*, 1835–1895.

24. *An Illustrated History of Los Angeles County: containing a history of Los Angeles County from the earliest period of its occupancy to the present time, together with glimpses of its prospective future . . . and biographical mention of many of its pioneers and also of prominent citizens of to-day* (Chicago: The Lewis Publishing Company, 1889), 438.

25. "What Los Angeles Looked Like in 1881," *Los Angeles Times*, August 4, 1889, 1.

26. Mount Pleasant is the name of the neighborhood where the hotel is located. It was also the name of a tract developed by George Cummings, and in 1894 the Cummings Hotel became the Mount Pleasant Hotel.

27. "Boyle Heights: Brief Sketch of a Delightful Suburb," *Los Angeles Times*, August 4, 1889, 10–11.

28. "Buildings, Concise Statement of the Improvements of 1889," *The Los Angeles Times*, January 1, 1890, 10.

29. "Boyle Heights Celebrates its Ethnic Diversity," *Los Angeles Times*, Local News, February 22, 2010, http://articles.latimes.com/2010/feb/22/local/la-me-boyle-heights22–2010feb22.

30. Metro, "State of Jalisco, Mexico, donates 17 wrought iron benches for Mariachi Plaza in Boyle Heights," May 15, 2001, http://www.metro.net/news/simple_pr/state-jalisco-mexico-donates-17-wrought-iron-1.

31. Evangeline Ordaz-Molina, e-mail message to author, April 11, 2011.

32. In-person conversation with author, Los Angeles, June 14, 2012.

33. Translated loosely, these mean "My God, upon my soul!"

A Paean to Santa Cecilia, Her Fiesta, and Her Mariachis

1. All translations of song lyrics by the author.

2. One of the most complete and well documented histories of mariachis is Jesús Jáuregui's *El Mariachi: Símbolo Musical de México* (México: Instituto Nacional de Antropología e Historia, 2007).

3. Ibid., 52. Mariachis have been a feature of political campaigns ever since.

4. Álvaro Ochoa Serrano *Mitote, fandango y mariacheros* (Ocotlán, Jalisco: Centro Universitario de la Ciénega, Universidad de Guadalajara, [1994] 2008), 93. Ochoa Serrano both captures and evokes the fanciful and profound nuances of mariachi culture in his writing.

5. Daniel Sheehy, *Mariachi Music in America: Experiencing Music, Expressing Culture* (New York: Oxford University Press, 2006), 51. This book is used in mariachi education programs across the nation.

6. The *china poblana* is the typical young woman from Puebla: young, beautiful, and strong, who exemplifies the national ideal of those qualities. "China" has nothing to do with Asia, but is rather is an old mixed-caste term that in modern times denotes both endearment and wavy hair. Reyes's extravagantly colored dresses typically have national symbols embroidered on them.

7. These and other verses relating to Los Angeles and California were collected by Álvaro Ochoa Serrano in "Mariache/i con la musica a otra parte," in *Memoria del Coloquio el Mariachi y la musica tradicional de méxico. De la tradición a la innovación,* ed. Arturo Camacho Becerra, 19–29 (Guadalajara: Secretaria de Cultura-Gobierno de Jalisco, 2010). Translations by the author.

8. Ibid., 25.

9. "tan-TAN" is the way musicians and others vocalize what is played on instruments—the trademark staccato cadence that ends mariachi and other kinds of Mexican songs, with a subdominant eighth note leading into the tonic quarter note, then silence.

Bibliography

Abstract of Title of that certain Real Property in the City of Los Angeles, County of Los Angeles, State of California, bounded and described as follows: Lands of Sacramenta Lopez de Cummings and George Cummings, her husband, East of the Los Angeles River, 1835–1895, filed Jan 15, 1895. File: "Cummings Tract, 2/1/36–Dec.1894," Box B 2288 "Abel Stearns." Los Angeles City Archives, Edwin C. Piper Technical Center.

Bancroft, Hubert Howe. *Register of Pioneer Inhabitants of California 1542–1848*. Los Angeles: Dawson's Book Shop, 1964.

Barras, Judy. *The Long Road to Tehachapi*. 4th ed. Tehachapi, CA: Anne Marie and George W. Novinger, 2002.

Belderraín, Francisca López de. "The Awakening of Paredón Blanco Under a California Sun." *Annual Publication of the Historical Society of Southern California* 14, no. 1 (1928): 64–79.

Belderraín, María Francisca López de. "A Short Biography of Francisco Lopez the Discoverer." Affidavit signed June 5, 1930. San Marino, CA: Henry E. Huntington Library.

———. The True History of the First Discovery of Gold in California in 1842."Affidavit signed June 5, 1930. San Marino, CA: Henry E. Huntington Library.

Confirmations by Junípero Serra, Mission San Gabriel. Photocopy courtesy Robert E. López in Catherine L. Kurland files.

Crosby, Harry W. *Antigua California: Mission and Colony on the Peninsular Frontier, 1697–1768*. Albuquerque: University of New Mexico Press, 1994.

Cummings, Maria S. López de. *Claudio and Anita*: *A Historical Romance of San Gabriel's Mission Days*. Los Angeles: Rowney Press, 1921.

Deed, Petra Barrelas [Varelas] and Leandro López to Andrew A. Boyle, April 26, 1859. Workman Family Collection. Photocopy in Catherine L. Kurland files.

Deverell, William. *Whitewashed Adobe*: *The Rise of Los Angeles and the Remaking of Its Mexican Past*. Berkeley: University of California Press, 2005.

Estrada, William David. *The Los Angeles Plaza*: *Sacred and Contested Space*. Austin: University of Texas Press, 2008.

Griswold del Castillo, Richard. *The Los Angeles Barrio 1850–1890: A Social History*. Berkeley: University of California Press, 1979.

Hackel, Steven W. "Land, Labor, and Production: The Colonial Economy of Spanish and Mexican California." In *Contested Eden*: *California Before the Gold Rush*, edited by Ramón Gutiérrez and Richard J. Orsi, 111–46. Berkeley: University of California Press, 1998.

An Illustrated History of Los Angeles County: containing a history of Los Angeles County from the earliest period of its occupancy to the present time, together with glimpses of its prospective future . . . and biographical mention of many of its pioneers and also of prominent citizens of to-day. Chicago: Lewis Publishing Company, 1889.

Insurance Maps of Los Angeles, California, 1888. Vol. 2, sheet 71a. New York: Sanborn-Perris Map Company, 1888.

Insurance Maps of Los Angeles, California, 1894. Vol. 2, sheet 87a. New York: Sanborn-Perris Map Company, 1894.

Jáuregui, Jesús. *El Mariachi: Símbolo musical de México.* México: Instituto Nacional de Antropología e Historia, 2007.

Layne, Joseph Gregg. *Annals of Los Angeles From the Arrival of the First White Men to the Civil War, 1769–1861.* San Francisco: California Historical Society, 1935.

Los Angeles City and County Directory, 1886–1887. Los Angeles: A. A. Bynon & Co., 1886.

Los Angeles City. "Map of Two Parcels of land in the City of Los Angeles belonging to F. Lopez." Los Angeles City Archives, Edwin C. Piper Technical Center, Box 96, 1877, vol. XIII, p. 315.

Los Angeles City. Untitled Records. Los Angeles City Archives, Edwin C. Piper Technical Center, Boxes 95 and 96, 1877. vols. XII, XIII.

Mason, William M. *Los Angeles Under The Spanish Flag: Spain's New World.* Produced as a complement to *Spanish-Mexican Families of Early California*, vol. 3. Burbank, CA: Southern California Genealogical Society, 2004. http://www.scgsgenealogy.com/storage/Northrup3.pdf.

Newmark, Harris. *Sixty Years in Southern California, 1853–1913.* New York: Knickerbocker Press, 1916.

Ochoa Serrano, Álvaro. "Mariache/i con la música a otra parte." In *Memoria del Coloquio el Mariachi y la música tradicional de México.*

De la tradición a la innovación, edited by Arturo Camacho Becerra, 19–29. Guadalajara: Secretaria de Cultura-Gobierno de Jalisco, 2010.

———. *Mitote, fandango y mariacheros.* Ocotlán, Jalisco: Centro Universitario de la Ciénega, Universidad de Guadalajara, [1994] 2008.

Robinson, W. W. *Land in California: The Story of Mission Lands, Ranchos, Squatters, Mining Claims, Railroad Grants, Land Scrip, Homesteads.* Berkeley and Los Angeles: University of California Press, 1948.

Sánchez, George J., *Becoming Mexican American: Ethnicity, Culture and Identity in Chicano Los Angeles, 1900–1945.* New York: Oxford University Press, 1993.

Sandoval-Strausz, Andrew K. *Hotel: An American History.* New Haven, CT & London: Yale University Press, 2007.

Shearer, Hannah L. "Dorothy Cummings Coyner: A Portrait in Words." Unpublished paper, June 1994. Collection of Catherine L. Kurland.

Sheehy, Daniel. *Mariachi Music in America: Experiencing Music, Expressing Culture.* New York: Oxford University Press, 2006.

Spitzzeri, Paul R. *The Workman & Temple Families of Southern California, 1830–1930.* Dallas: Seligman Publishing, 2008.

Workman, Boyle. *The City that Grew.* Los Angeles: Southland Publishing, 1935.

Contributors

Miguel A. Gandert

Nuevomexicano documentary and art photographer Miguel Gandert went to Boyle Heights with Catherine López Kurland in 2007 to document the Cummings "Mariachi" Hotel before it was demolished. The most poignant part of the story has a human face—the intangible cultural legacy of generations of mariachis whose home base has long been known as Mariachi Plaza de Los Angeles. Over the next several years, lament turned to triumph, thanks in part to his inspirational photographs, which were used for fundraising.

Gandert continues to use traditional black-and-white film and sees documentary work as both a form of art with a strong capacity for expression and as a way of telling stories and understanding complex cultural relationships. To him, photography gives voice to the voiceless and tells community stories that have been forgotten or ignored, but are profoundly important to the modern world.

Gandert's work has been shown in galleries and museums internationally, and it is in a number of public collections, including the Boston Museum of Fine Arts, the Smithsonian Museum of American History, the Center for Creative Photography in Tucson, Yale's Beinecke Rare Book & Manuscript Library, and the New Mexican Museum of Art in Santa Fe, and was selected for the 1993 Biennial Exhibition at the Whitney Museum of American Art in New York. His book *Nuevo México Profundo, Rituals of an Indo-Hispano Homeland* (Santa Fe: Museum of New Mexico Press, 2000) accompanied the inaugural exhibit of the National Hispanic Cultural Center in Albuquerque. Gandert is committed to multidisciplinary work and has collaborated with a variety of renowned scholars, including Enrique Lamadrid. Gandert is Distinguished Professor and director of the Interdisciplinary Film and Digital Media program at the University of New Mexico.

Catherine L. Kurland

Catherine L. Kurland left her hometown of Los Angeles after graduating from the University of Southern California, not returning to the West until 2004, when she and her husband decided on a whim to move to Santa Fe, New Mexico. Before her return to the Spanish Southwest, Kurland lived in New York, where she co-owned Kurland•Zabar, the first gallery in the United States to specialize in the British arts & crafts movement. At about the time she began her graduate studies in historic preservation at the University of New Mexico, Kurland chanced upon the Cummings Hotel in Los Angeles, which her great-grandparents had built in 1889. To her amazement, the old brick building was still standing in remarkable original, if derelict, condition—filled with mariachi musicians! Her determination to save the endangered structure from demolition and to restore its historic character led Kurland to uncover her deep roots in the old Spanish and Mexican *pueblo* of Los Angeles and opened her heart to the musicians whose intangible heritage she has worked to preserve. Kurland, a historic preservationist, is the executive editor of El Camino Real de Tierra Adentro Trail Association's quarterly journal, *Chronicles of the*

Trail, recipient of the State of New Mexico's Heritage Preservation Publication Award.

Enrique R. Lamadrid

Enrique Lamadrid succumbed to the lure of California like generations of Nuevomexicanos before him. Two days after getting his driver's license in 1964, he drove historic Highway 66 all the way to the Pacific Ocean and jumped in. As a graduate student at the University of Southern California, he lived in downtown L.A. and walked the hills above Chávez Ravine, not for baseball but for history. Julián Chávez of Abiquiú, New Mexico, had settled there following his escape from execution for his part in the New Mexico Rebellion of 1837. Retracing his path, Lamadrid rode a motorcycle on the so-called Old Spanish Trail from Los Angeles and San Gabriel over El Cajón pass up through southern Utah down the Río Chama Valley to Abiquiú and Santa Fe.

As a folklorist and musicologist based at the University of New Mexico, Lamadrid's fieldwork has led him south in search of more recent traditions, including the mariachis. He was co-curator of the International Camino Real International Heritage Center in Socorro, New Mexico. His research on mestizo cultures culminated in his acclaimed book *Hermanitos Comanchitos: Indo-Hispano Rituals of Captivity and Redemption* (Albuquerque: University of New Mexico Press, 2003), which was awarded the prestigious Chicago Folklore Prize for ethnographic writing. The American Folklore Society granted him the Américo Paredes Prize for his cultural activism, and the Historical Society of New Mexico awarded him the Gilberto Espinosa Prize for historical research and the Pablita Velarde Prize for children's literature. He has collaborated on many field-based projects with photographer Miguel Gandert. Distinguished Professor Enrique R. Lamadrid is chair of the Department of Spanish and Portuguese at the University of New Mexico.

Evangeline Ordaz-Molina

A native of East Los Angeles, Evangeline Ordaz-Molina was one of the four founders of the East LA Community Corporation (ELACC), a nonprofit community development corporation located in Boyle Heights less than a mile from where she was born. Evangeline served on the ELACC board for twelve years and spent the last four on staff as ELACC's vice president and general counsel. Evangeline is also a playwright whose plays about Latino immigration have been produced throughout the Southwest. She is currently working on a play about Los Angeles, commissioned by the Center Theater Group (Mark Taper Forum, Ahmanson Theater, Kirk Douglas Theater). A member of the California Bar, Evangeline practiced law in the areas of human rights, government benefits, and housing rights. She currently serves on the City of Los Angeles Affordable Housing Commission.